BOSTON
MISCELLANY

BOSTON MISCELLANY

An Essential
History of the Hub

William P. Marchione

Charleston London

THE
History
PRESS

Published by The History Press
Charleston, SC 29403
www.historypress.net

First published 2008

Manufactured in the United States

ISBN 978.1.59629.587.2

Library of Congress Cataloging-in-Publication Data

Marchione, William P., 1942-
 Boston miscellany : an essential history of the Hub / William P. Marchione.
 p. cm.
 ISBN 978-1-59629-587-2
 1. Boston (Mass.)--History--Miscellanea. 2. Boston (Mass.)--Biography. I. Title.
 F73.35.M37 2008
 974.4'61--dc22
 2008035236

Notice: The information in this book is true and complete to the best of our knowledge. It is offered without guarantee on the part of the author or The History Press. The author and The History Press disclaim all liability in connection with the use of this book.

Contents

CONTENTS

Preface

These thirty columns on aspects of Boston's history were written in the period 1998 to 2002, when I was contributing regular bimonthly historical columns to the *Boston Tab* newspaper.

I have always had a deep interest in the history of Boston, going back to my childhood when I made daily trips with my father to the downtown, where my mother and her sister ran a corset and dressmaking establishment in the old Philips Building at 120 Tremont Street (on the site now occupied by the Suffolk Law School library). While my father (an insurance agent who worked primarily in the mornings and evenings) waited for my mother and aunt to close up their shop for the day, and was content to remain in his car on Hamilton Place, usually reading a newspaper or napping, I occupied these stints exploring Boston's downtown.

My peregrinations took me to whatever byways were within convenient walking distance: sometimes up Park Street to the Bulfinch-designed Massachusetts State House, where I would sit in the House gallery watching our dilatory legislature at work; then, perhaps, wandering through the narrow streets of the legendary Beacon Hill, headquarters of Boston's Yankee elite; or, on occasion, setting off in the opposite direction, to penetrate the commercial heart of the city, the area now called Downtown Crossing, via the back entrance of the Gilchrist's Department Store; or I might meander through the historic Boston Common and Public Garden, stopping to examine its various memorial installations; or possibly wind my way down Bosworth and Province Streets to the historic Province Steps, and then sit for awhile in one of the pews of King's Chapel, a building redolent with the atmosphere of Provincial Massachusetts. Another occasional destination would be Old City Hall, where on Mondays one

could be entertained by the verbal pyrotechnics of Boston's often-colorful politicians; or I might seek out such nearby Freedom Trail landmarks as the Old South Meetinghouse, the Old State House and Faneuil Hall, or the Brattle Book Shop in its original location in the Sears Crescent or even occasionally penetrate into the gritty Scollay and Dock Squares areas adjacent to the then-noisome and smelly Quincy Market, before its transformation into Boston's principal tourist mecca.

Thus I gained, between the ages of eight and fifteen in the period 1951 to 1957, not only an abiding appreciation of the historical richness of Boston but also a lifelong curiosity. This interest in Boston history has manifested itself primarily in an active career as a teacher, writer and public lecturer on Boston-area topics. Thus it was that when I got around, in 1994, to completing a Ph.D., I selected urban history as my primary field of concentration, with special emphasis on Boston.

A word of explanation about the organization of *Boston Miscellany*. While these thirty columns have been organized under five semichronological headings, none of these categories is self-contained; the subject matter of these pieces often intrudes into earlier or later periods of Boston's history.

In short, the topics dealt with were selected because they interested me, and because I wished to share what I had learned about them with the readers of my column. Each column was intended to stand by itself. While it is hoped that this volume's organizational framework, together with the short introductory essays appearing at the beginning of each part, will serve to weave this loosely knitted collection into a more coherent whole, it should be viewed by its readers primarily as a Boston miscellany, in keeping with its title.

Part I

Early Boston

Boston was founded in 1630 in the early stages of the Puritan migration. The settlement, situated on a small peninsula of less than eight hundred acres, quickly assumed, by virtue of its location on the best harbor in southern New England and centrality on Massachusetts Bay, a dominant economic and political position in the New England region. By the mid-1600s, Boston had risen to the status of first city in British North America, both from the standpoint of its population and the volume of its trade, a position it would retain until the mid-eighteenth century.

The first six columns of *Boston Miscellany* deal with aspects of the early development of Boston—the story of the fascinating and colorful William Blackstone, the first European to settle on the site that would afterwards be named Boston; and the rise of the neighboring community of Watertown, with its contrasting attributes, Massachusetts's early "Gateway to the West." Then, in turn, I describe the histories of three of Boston's most important neighborhoods—North Square in Boston's North End (its history so rich that I felt obliged to present it in two installments); Beacon Hill, once the least desirable of the city's neighborhoods, now arguably the most desirable; and finally Fort Hill, a neighborhood that once stood directly on Boston's waterfront, serving as a defensive bastion, then a fashionable neighborhood, then a festering slum until finally, in the 1860s, it was totally obliterated in Boston's first major urban renewal project, the historic hill itself disappearing in the process. It is hoped that these accounts of the early history of the Hub will give the reader an enhanced appreciation of the incredible richness and complexity of Boston's history.

William Blackstone: The First Bostonian

The historically minded are probably aware that an Anglican clergyman named William Blackstone was living on the site of Boston when the city's Puritan founders arrived in 1630, and that his farm, which he sold to the town in 1634, now comprises the Boston Common. But there is much more to the story of Blackstone than that.

William Blackstone was also the first Englishman to settle in what is now Rhode Island, ahead of Roger Williams by two years; the first English missionary to the Indians of southern New England, ahead of John Eliot and Thomas Mayhew by two decades; and the first New England horticulturalist and pomologist. Blackstone's was a fascinating life that deserves to be better known.

William Blackstone was born in 1595 in Whickham, Durham, England, the son of a prosperous landowner. Intended for the clergy, William enrolled at Emmanuel College, Cambridge University, where he earned a BA in 1617 and an MA in 1621. Upon completing his studies, he immediately took orders in the Church of England.

Uncomfortable with some aspects of Anglican practice, in 1623 the independent-minded Blackstone left England permanently. He joined an expedition under the leadership of Captain Robert Gorges that established a

An artist's conception of the first house in Boston, built in the mid-1620s—Reverend William Blackstone's cottage on the southwestern slope of Beacon Hill.

colony at Wessagusett (now Weymouth) on Massachusetts Bay. The attempt soon foundered, however, with most of the adventurers either returning to England or relocating at Jamestown, Virginia. A few remained in the general area. One of these was William Blackstone.

Taking some of the supplies and cattle that the Wessagusett group had abandoned, Blackstone moved fifteen miles up the coastline to the Shawmut Peninsula, and built a thatch-roofed cottage on the sunny southwestern slope of Beacon Hill, laying out a garden and an orchard (the first orchard in New England) next to this primitive abode. The precise date of Blackstone's arrival on the peninsula is uncertain but was no later than 1626.

Blackstone's house on Beacon Hill overlooked the broad tidal marshes of the Back Bay. It was a truly idyllic setting, as writer Lucius Beebe has written, for it allowed Blackstone to

> *lie abed late in the mornings,* [since] *the sun did not strike through his windows until some little time after it had risen over Massachusetts Bay, and his evenings were long and peaceful, the only sounds being the animated croaking of frogs in the meadows where Charles Street now runs and the gulls which screamed as they wheeled in search of fish over the Roxbury Flats.*

Here the bookish clergyman (his 187-volume collection was said to be the largest in the English colonies) lived a solitary existence until 1630. While there were a few Englishmen in the general area—Samuel Maverick at Chelsea, William Jeffries and John Bursley at Weymouth and some others at Hull, Quincy and Charlestown—Blackstone saw little of his white neighbors. The natives of the area, more numerous and closer at hand, were more often his companions. He sought to convert them to the Christian religion (the Church of England was always far more interested in missionary endeavors than the Puritans), thereby becoming the pioneer missionary to the Indians of the region.

This solitary lifestyle ended in mid-1630 when twelve ships, carrying some one thousand Puritan settlers, arrived in Boston Harbor. Little did Blackstone realize how much grief these Puritans would cause him.

Craving contact with other Englishmen after so many years of isolation, Blackstone hastened to Charlestown, where the Puritans were temporarily encamped, to acquaint them with the excellent spring that existed on Shawmut (the limited water supply at Charlestown having contributed to an outbreak of disease there), and to invite any who were of a mind to do so to become his neighbors.

One of the Puritan leaders, Sir Isaac Johnson, an old acquaintance, took up this invitation and immediately moved in with Blackstone. Before long, Governor John Winthrop, the Reverend John Wilson and most of the members of the Charlestown church followed suit, making the Shawmut Peninsula the headquarters of the Massachusetts Bay government. On September 7, 1630, the name Boston was adopted for this settlement.

There was friction between Blackstone and his neighbors from the first. The founders of the Massachusetts Bay Colony had come to New England to escape the influence and authority of the Anglican Church, only to find one of its preachers in possession of the most valuable parcel of real estate on the Massachusetts shore.

Pressured to conform to Puritan doctrine and practices, the independent-minded Blackstone grew increasingly resentful. "I left England," he declared angrily, "to get away from the power of the lord bishops, but in America I am fallen under the power of the lord brethren."

In 1633, Blackstone's deteriorating relationship with the Puritans grew worse when the authorities deprived him of all but fifty acres of his Boston land. Concluding that there could be no secure future for an Anglican in the City of the Puritans, in 1634 Blackstone sold all but six acres of his farmstead to the town government (the forty-four-acre parcel becoming the Boston Common).

Packing up his belongings—some cattle, furniture, his library and a supply of apple tree shoots—Blackstone headed southwest into the wilderness along an Indian trail corresponding to present-day Route 1. Passing into Plymouth Colony, he chose a site at a bend on a river (afterwards named the Blackstone River) in what is now the Village of Lonsdale, Cumberland, Rhode Island, and built a cabin. This home he named Study Hill. Blackstone thereby became the first Englishman to settle in Rhode Island.

Blackstone's lifestyle at Study Hill very much resembled that of his Boston years prior to the arrival of the Puritans. He gardened, tended his apple orchard, read, went out on long walks and sought to convert his Indian neighbors to Christianity. Tradition tells us that Blackstone traveled to the various Indian settlements on the back of a saddle-trained white bull, and that he gave apples from his orchard to the natives as gifts. Apples, a rarity in early New England, were highly valued. In his Study Hill orchard, this pioneer horticulturalist raised the first new strain of apples in North America, known as yellow sweetings.

In 1636, Blackstone's solitude was again threatened when Roger Williams and a band of religious dissenters established themselves at Providence, just six miles to the south. This intrusion proved much less troublesome, however. Though the religious views of Williams and Blackstone were quite different, Williams was far more tolerant than the Puritans of Massachusetts Bay. The two

men, in fact, formed a close friendship, and Williams often invited Blackstone to preach in Providence and at the colony's trading station at Wickford.

Blackstone returned to Boston frequently over the years. He still owned several acres on Beacon Hill, formerly the site of his cottage and orchard. This land is today enclosed by Beacon Street to the south, Spruce Street to the east, Pinckney Street to the north and Charles Street to the west. It included the site of Louisburg Square. Not until the late eighteenth century was much value attached to this property, then fairly remote from the commercial heart of Boston. Today, of course, it lies at the center of the most fashionable of Boston neighborhoods. Prominent Bostonians who afterwards lived on this historic parcel included John Singleton Copley, Harrison Grey Otis, William Ellery Channing, William H. Prescott, Francis Parkman, Charles Francis Adams and David Sears.

Boston locations that commemorate the first Bostonian include Blackstone Street, in the market district, and Blackstone Square, which was laid out in the South End in 1832. In addition, a Blackstone Point once existed near the present-day intersection of Pinckney and Charles Streets.

It was during one of Blackstone's visits to Boston, in 1659, that the elderly bachelor finally took a wife, Sarah Stephenson, widow of John Stephenson of Milk Street, with whom he soon afterwards fathered a son. Blackstone

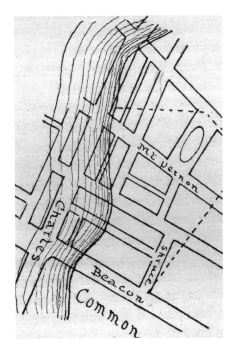

This map shows the boundaries of Blackstone's six-acre property on Beacon Hill of which he retained ownership after leaving Boston in 1634. The bulk of his land was sold to the town government in 1634 to become the Boston Common.

was sixty-four years of age at the time of his marriage to Sarah, which lasted fourteen years, until her death in 1673 at Study Hill. Blackstone himself died there on May 26, 1675, in the eightieth year of his life.

We would know much more about William Blackstone had it not been for King Philip's War, the most devastating Indian conflict in New England history, which erupted at the very moment of his death. A few days after Blackstone's demise, King Philip's rampaging braves descended upon Study Hill, and burned not only Blackstone's house and library, but also his personal papers.

As Charles Francis Adams wrote of this unfortunate event, "[Blackstone] left among his effects 10 paper books, whose destruction…when the Indians burned his house, we must regret, as containing possibly some record of his mysterious career." Even in the absence of such details, however, William Blackstone, the first Bostonian, emerges as one of the most fascinating figures in the early history of New England.

Watertown: First Settlement on the Charles

Settlement on the banks of the Charles River by English colonists began in late July of 1630, when a group of families under the leadership of Sir Richard Saltonstall established Watertown on the site of Gerry's Landing at the southwestern corner on what is now Cambridge. Watertown's foundation predated that of Boston by a matter of weeks and that of Newtowne (Cambridge) by more than three months.

Title to the Charles River Basin area was in dispute. Claimants included the merchant John Oldham—a resident of Nantasket on the Hull Peninsula—who held a land patent of somewhat dubious legality to a major portion of the Charles River Valley, and the Massachusetts Bay Colony government, then in the process of establishing settlements along the Massachusetts shore and its various rivers.

The earliest attempt at settlement on the Charles had come some weeks before the arrival of the Saltonstall group, when ten men (the so-called Dorchester Men) established themselves on the northern bank of the river in Watertown. These Dorchester Men—120 in all—had arrived at Nantasket aboard the vessel *Mary & John* on May 30, 1630. A few days later, they sent ten of their number to explore the Charles River Basin for a settlement. Oldham encouraged them to explore the Charles, hoping that their presence there would strengthen his claim to the disputed acreage.

After stopping briefly at Charlestown, where a tiny community of Englishmen already lived, the Dorchester Men moved up the Charles, where, according to the chronicler of their expedition, Roger Clap, "the river grew

narrow and shallow, and there we landed our goods with much labor and toil, the bank being steep." The point they chose for their encampment lay on the hillside directly behind the present-day Perkins Institute for the Blind.

It had been a long journey and by the time the Dorchester Men disembarked on this steep embankment, dusk was setting in. Their approach had not gone unnoticed and about three hundred natives (members of the Pequosette Tribe) had gathered nearby, which caused great anxiety among the English. An "old planter" who could speak the Indian tongue (very possibly John Oldham, who may have accompanied the Dorchester group), was sent to warn the Pequosettes not to approach the English camp that night. Fortunately, wrote Clap, the "natives hearkened to his advice, and came not."

The following morning, when the Indians entered the English camp, they indicated their peaceful intentions, wrote Clap, by "hold[ing] out a great bass to us, which the white men accepted, giving in return a biscuit cake." This widely depicted first contact of English and natives on the Charles provides the motif for the Watertown Town Seal.

Clap and his associates made good progress in preparing the Charles River site as a permanent home for the Dorchester Men. Within a few days, wrote Clap, "the men built a kind of shelter to store our goods in and preparations for the arrival of the main group were well advanced."

Watertown was a highly desirable location for a permanent settlement for several reasons: one, the area was extremely fertile and offered a large supply of fodder for livestock raising; two, the river would provide the settlement

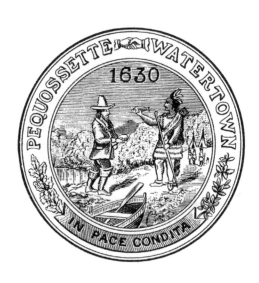

The motif of the Watertown Town Seal, designed by the great architect Charles Brigham, shows local Indians welcoming the Dorchester Men as they landed on the north bank of the Charles River in Watertown in early June 1630, on a site behind the present Perkins Institute building; this was the first attempt to establish an English settlement on the Charles.

with a natural highway to the coastline where other Englishmen already resided (Salem, Charlestown, Plymouth), while its interior location would give a group living there a measure of security against amphibious attacks (a matter of very great concern in that period of intense colonial rivalries); and three, the best fishing grounds on the Charles existed almost directly opposite the site the Dorchester Men had selected—a location later called the Weirs. Here huge quantities of bass, salmon and herring could be gathered in season, providing a critically important source both of food and of fertilizer for the agricultural economy the settlers expected to establish there.

However, Massachusetts Bay Colony Governor John Winthrop interpreted the presence of the Dorchester Men on the Charles as both a challenge to the authority of the Massachusetts Bay government and a threat to its title to the Charles River acreage. Since the Dorchester Men had come to Massachusetts Bay under the auspices of his government, Winthrop was in a position to order their removal, which he did immediately. Thus only a few days after their arrival, the Dorchester Men were obliged to abandon the Charles River site. Instead they settled just south of Boston, where they founded the town of Dorchester.

The man who established Watertown under Massachusetts Bay Colony auspices in late July 1630, Sir Richard Saltonstall, was a member of the Yorkshire landed gentry, a close associate of Governor Winthrop and one of the original patentees of the Massachusetts Bay Colony. One of only two knights among the Bay Colony's founders (the other being Sir Isaac Johnson of Boston), about one hundred settlers placed themselves under this prestigious leader in founding Watertown.

The Saltonstall group selected Gerry's Landing as a settlement site—the point where the Eliot Bridge now crosses the river just west of Mount Auburn Hospital, about two miles east of where the Dorchester Men had set up their short-lived camp two months earlier. Here the topography was strikingly different from the upriver location—a relatively flat area, subject in its lower reaches to tidal flooding, quite open (owing to the Indian practice of regularly burning the underbrush), highly fertile and extremely well watered with numerous streams and ponds.

A number of sources describe the original site of Watertown as parklike in character, the natives having left the larger trees intact. The first settlers at Saltonstall's Plantation (as Watertown was at first called) did not live in a nucleated village but instead established widely scattered farmsteads covering the entire area between the landing site and Fresh Pond.

As previously noted, most of the land on which Watertown's founding families settled now lies in Cambridge, for the southeastern portion of Watertown was in 1754 ceded to Cambridge as part of a border adjustment.

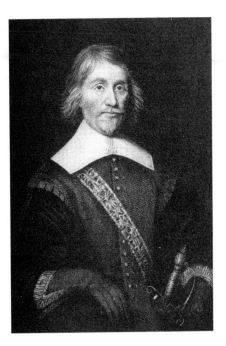

Sir Richard Saltonstall, who led the group of one hundred settlers who founded Watertown at Gerry's Landing (in present-day Cambridge) in late July 1630—the first permanent settlement on the Charles River.

Sir Richard Saltonstall, the founder of the town, resided in Watertown only very briefly, returning to England permanently in 1631. Another distinguished pioneer settler was the Reverend George Phillips, one of the two ordained ministers among the 1630 Massachusetts Bay settlers.

Interestingly, one of the earliest land grants in Watertown went to the merchant John Oldham: a five-hundred-acre parcel that included the site where the Dorchester Men had established their camp in June, compensation perhaps for the negation of his claim to so many thousands of Charles River Valley acres. In any event, Oldham accepted the grant and resided contentedly in Watertown for four years, became a member of Reverend Phillip's church and even served as Watertown deputy to the First General Court of Massachusetts. Oldham left Watertown in 1634 as leader of the group of settlers that founded the town of Wethersfield on the Connecticut River.

The focal point in Watertown gradually shifted from Gerry's Landing to more westerly areas of the town as the years passed, as reflected in the sites selected for its various meetinghouses. The first Watertown Meetinghouse, which served from 1630 to 1635, stood near Gerry's Landing. In 1635, the meetinghouse was moved to a location at the northwest corner of Mount Auburn and Arlington Streets, nearly a mile to the west. Its third location, dating from 1754, was the intersection of Mount Auburn and Common Streets, much closer to Watertown Square.

This progressively westward shift in Watertown's center of gravity reflected the growing importance of Watertown Square to the local economy.

In 1634, the town hired Thomas Mayhew of Medford to build a stone dam, raceway and gristmill on the north bank of the Charles, just west of the square, where a set of rapids could be harnessed to generate water power. This gristmill quickly became the commercial and industrial heart of the town. As the only gristmill in the general area, it was of importance not only to the residents of Watertown, but generally to the people of the western end of the Charles River Basin.

Watertown Square had importance also by virtue of its location at the westernmost point of the Charles River tidal estuary. Vessels could bring passengers and goods up the Charles as far as Watertown Square, but here rapids interrupted the river's function as an artery of transportation and commerce. Beyond the square, the river narrowed and also meandered aimlessly in a generally southwesterly direction, making it much less commercially serviceable. From the Watertown Square locale, however, several major roads radiated in a westerly direction.

Thus Watertown became a "Gateway to the West" in the early years of Massachusetts Bay Colony—a point of departure for countless overland expeditions sent out to people central Massachusetts and the Connecticut River Valley. One of the most important of these was the 1636 expedition led by Reverend Thomas Hooker that founded Hartford and the Connecticut Colony.

The Annals of Old North Square

North Square in Boston's North End, the site of the Paul Revere House, has had an amazing history that deserves to be better known. Located at the intersection of North and Prince Streets, this tiny square has a significance all out of proportion to its diminutive size. Moreover, it has experienced transforming changes—from the "Court End of Town" in the early eighteenth century (where Boston's richest merchants resided), to a zone of emergence for successive waves of impoverished immigrants in the nineteenth century, to the trendy tourist mecca of the present day.

North Square's colonial prominence derived chiefly from two factors: the establishment at its northern edge in 1650 of Boston's Second Church, the original Old North (sometimes also called the Church of the Mathers), and the square's proximity to several of the city's most important wharves. In addition, North Square was the site of an early public market.

Early Boston

From the pulpit of the Boston's Second Church in North Square, the influential Mathers, the most important family of ministers in colonial Boston, exerted a powerful influence upon both the religious and political life of the community (the two spheres then being closely intertwined). The Mather family's residence stood on the site of the Paul Revere House until 1676, when that dwelling, the church, the public market and much of the surrounding area was destroyed in a devastating fire. However, the neighborhood quickly reemerged from the ashes to attain even greater distinction.

The first member of the Mather family to preside over the Second Church was Increase Mather of Dorchester, who was called to its pulpit in 1664, a post he occupied for the next fifty-nine years. One source tells us that Increase was "unequaled in reputation and power by any native-born American clergyman of his generation." After 1685, he also served as rector and president of Harvard College, and in 1690 was sent to England as an agent of the Massachusetts Colony, where he succeeded in obtaining a new charter (the old one having been revoked by the king in 1688) that restored many of Massachusetts's lost liberties.

That Boston's Puritan leadership felt much less concern for personal liberties than political liberties is suggested by the harsh punishment they meted out to a certain Captain Kemble of North Square in the mid-seventeenth century.

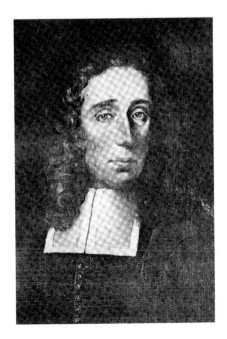

Reverend Increase Mather, the great clergyman who presided over Boston's Second Church in North Square from 1664 until his death in 1723. Mather simultaneously served as rector and president of Harvard College.

The errant captain was condemned to stand in the stocks for two hours for lewd and unseemly conduct, because he had impulsively kissed his wife on the front steps of their home on the Sabbath day, upon returning from an absence at sea of three years.

Even more distinguished as a scholar (if not as a politician) than Increase Mather was his son, Cotton, who served as an associate minister of the Second Church from 1685 until his elder's death in 1723, and then succeeded him as principal minister. Cotton Mather was a prolific writer who published more than 450 books and religious tracts. His chief work, the *Magnalia Christi Americana* (1702) has been called "the mightiest American literary achievement up to its time."

Cotton Mather was also a complex personality who left a mixed historical record. While his early writings have been blamed for helping to incite the Salem witchcraft hysteria of 1692, which resulted in the execution of nineteen innocent people, the courageous support he gave Dr. Zabdiel Boylston, the early proponent of inoculation during the 1721 Boston Smallpox Epidemic, is credited with having saved many lives.

Cotton Mather's son Samuel, the last of the family to preside over the Second Church, was less distinguished than either of his forebears. The rigid and elitist religious and social views that the Mathers advocated were becoming less palatable by the third decade of the eighteenth century, and Samuel was forced out by his dissatisfied congregants in 1741.

North Square derived much of its economic vitality from the nearby North End waterfront, the site of several of Boston's most important wharves, especially Scarlett's and Clark's Wharves, and of several local shipyards. The most important of these commercial facilities were owned by the wealthy merchant William Clark, who in 1712 built a great mansion at the northwest corner of Garden Court and Prince Streets, the largest and most elegant residence in early eighteenth-century Boston. For much of that century, North Square was known as Clark Square after the great merchant. Only in 1788 was its name changed to North Square.

The Clark-Frankland Mansion (the house later served as the residence of Sir Harry Frankland, collector of the port of Boston) was an elegantly proportioned, three-story, brick Georgian-style edifice containing twenty-six richly furnished rooms. One source described it as "a monument to human pride," suggesting that Clark built it primarily to outdo his neighbors.

Almost equally elegant was the Garden Court residence of Colonel Thomas Hutchinson and his son and heir, Thomas Hutchinson the younger, who would later serve as the last civilian royal governor of Massachusetts Colony. It was the Hutchinson Mansion that was attacked and sacked by anti–

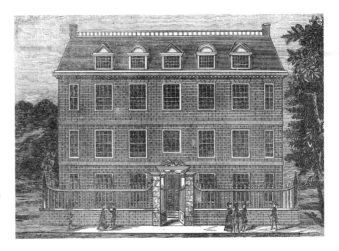

The Clark-Frankland House, built by wealthy merchant William Clark circa 1712, which stood on Garden Court in North Square, was the most elegant home in early eighteenth-century Boston.

Stamp Act rioters on the evening of August 26, 1765, forcing Hutchinson (then serving as lieutenant governor and chief justice of Massachusetts) to flee to safety through his garden.

North Square was to witness several other dramatic episodes in the years leading up to the outbreak of the Revolution. On June 10, 1768, Collector of Customs Joseph Harrison went to Hancock's Wharf (the former Clark's Wharf) to seize John Hancock's sloop *Liberty*, which he alleged had smuggled goods into Boston. Harrison arranged for the British warship *Romney* to tow Hancock's vessel away, which was quickly accomplished. Upon attempting to leave Hancock's Wharf, however, he and his deputies found themselves surrounded by a mob of outraged Bostonians, who proceeded to shower rocks and sticks upon the offending officials, dragged the collector through the town's open sewer and then marched on his residence and broke all of its windows.

In early 1770, the Patriot leader Paul Revere acquired the house in North Square that we associate with his name. The Revere family occupied this dwelling for only ten years, however, before moving to more ample quarters on Charter Street. That Revere had a genuine need for more space is suggested by his having fathered a total of sixteen children!

It was in the windows of Revere's North Square residence that he mounted illuminated transparencies dramatizing the horrors of the Boston Massacre of March 5, 1770, a display that was calculated to inflame public opinion against British authority and which probably contributed to the decision to transfer British troops from Boston to Castle Island in the harbor.

In Revere's time, incidentally, the house at 19 North Square had a very different appearance. When the Paul Revere Memorial Association

undertook its restoration in 1907–08, it was decided to return the building to its original seventeenth-century appearance, rather than the way it had looked at the time of the Revere family's occupancy, when it was already nearly a hundred years old. The Paul Revere House enjoys the distinction of being the oldest surviving building in Boston, dating from about 1680.

Several British officers lived in and around North Square at the time of the outbreak of the Revolution, including Major John Pitcairn, who commanded the force that fired on the Americans gathered on the Lexington Green on the fateful morning of April 19, 1775. Pitcairn's residence stood a short distance south of the Revere House. British soldiers had mustered in the square the previous evening in preparation for the expedition that launched the American Revolution.

Old North Square: Zone of Emergence

As Boston's population mushroomed in the early years of the nineteenth century, wealthy residents abandoned the older and more congested parts of the city, like North Square, for more fashionable, newer neighborhoods, such as the developing West End, Beacon Hill and the South End. Thus North Square, formerly the "Court End of Town," began its relentless decline from the status of *prestige neighborhood* to that of a crowded and noisome *zone of emergence* for consecutive waves of impoverished immigrants. This transformation was gradual, requiring more than a half century to unfold, but by 1850, the North Square area had socially, ethnically and religiously metamorphosed.

North Square lost one of its most important landmarks in the early stages of the Revolution, when the Second Church, the influential "Church of the Mathers," was dismantled by the British for firewood during the hard months of the siege of Boston. After the siege, instead of rebuilding, the congregation united with the New Brick Church on nearby Hanover Street. It was more than half a century before another house of worship arose in North Square, one altogether different from the staid and socially prestigious Second Church.

This new institution, the Sailor's Bethel, a Baptist church established in 1828 by the Boston Port Society, attended to the spiritual needs of the many mariners who found themselves temporarily in the port of Boston, for the North End waterfront was still quite active and vital. Its minister, the eloquent Reverend Edward Taylor (popularly known as Father Taylor) was one of the most powerful preachers of his day, in an era when Boston had

Early Boston

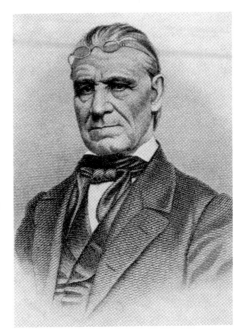

The Reverend Edward Taylor (popularly known as "Father Taylor") was one of the most powerful preachers of his day, in an era when Boston had more than its share of inspired clergymen. He presided over the Sailor's Bethel in North Square, a Baptist church established in 1828 by the Boston Port Society, which attended to the spiritual needs of the many mariners who found themselves temporarily in the port of Boston.

more than its share of inspired clergymen. As the historian Samuel Adams Drake noted of Father Taylor's sermons, "his discourses were filled with graphic illustrations from the language of the ocean and went straight to the comprehension of his hearers." Because sailors were in need of more than spiritual guidance, a mariners' house was opened in North Square in 1847, furnishing temporary lodging to these men of the sea.

Two of North Square's colonial landmarks were demolished in the 1830s—the once-elegant Hutchinson and Clark-Frankland mansions, which had fallen into serious disrepair. The attractive gardens that had once enclosed these great houses had long since filled up with modest structures. Father Taylor's residence, at the corner of Prince Street, was one of these.

Even more emblematic of the social decline of the neighborhood was the establishment by Reverend J.B. McMahon of the Moon Street Free Church, a Catholic institution catering to the city's poorest element, for by the 1840s, North Square was situated at the heart of Boston's largest neighborhood of poor immigrants, a population predominantly Irish in makeup.

The massive Irish immigration between 1845 and 1853 transformed Boston ethnically and religiously. From a mostly Yankee-Protestant city, the Hub became one-third Irish in short order. These Irish immigrants were mostly poor and often illiterate, unskilled, unused to living in cities and members of a church that many Bostonians regarded with hostility.

Of necessity, of course, the newcomers moved into the sections of the downtown that offered the cheapest accommodations. Since the supply of housing in Boston in the 1840s was rather limited, the city's older neighborhoods soon became overcrowded, disease-infested slums, none more so than North Square and the warren of streets that ran off of it. The very geography of the downtown, enclosed as it was by the waters of the harbor and of the Charles River, fostered the entrapment of the city's poor in these congested downtown neighborhoods.

By the late 1840s, living conditions in the North End were among the worst in the city. When a cholera epidemic ravaged Boston in 1849, most of the dreaded disease's seven hundred victims came from the Irish slums. The city's infant mortality rate also reached unprecedented heights in these years, with the city's immigrants as chief victims. In the 1860s, for example, three out of every ten infants born in the North End died before reaching the age of one.

The entrapment of the city's immigrants was more than a physical phenomenon. It was also social. Boston's Yankee Protestant ruling element developed a kind of siege mentality where the newcomers were concerned. They sought to have as little to do with them as possible—to keep them in their place socially as well as geographically on the lowest rung of the social ladder.

Despite such barriers, upward mobility did occur among the denizens of the North Square neighborhood. An excellent example lies in the life and career of John F. "Honey Fitz" Fitzgerald, the son of an Irish peddler, who was destined to become the maternal grandfather of a president of the United States. Fitzgerald was born in 1863 on Ferry Street, a stone's throw from North Square. A product of Boston public schools (the Eliot School on North Bennett Street and the prestigious Boston Latin School), he rose by stages from newspaper editor to the Boston City Council, to the Massachusetts State Senate, to the U.S. Congress and finally to the post of mayor of Boston. In 1889, the newly married Fitzgerald moved to 4 Garden Court just off of North Square, and it was there that his eldest child, Rose, the mother of John F. Kennedy, was born in 1890.

As early as the 1850s, Italian immigrants, mostly Genoese in background, had begun to settle along Ferry Court, a discontinued alleyway that once ran off of 24 Ferry Street, a short distance from North Square. From this small nucleus emerged the Italian community that by 1920 had come to dominate the entire North End, and that has left the most indelible ethnic imprint on that district (to the point that it is today often referred to as Boston's Little Italy).

Most indicative of the rise of the Italians to dominant status in North Square itself was the establishment in 1888, in the discontinued Seamen's Bethel Church, of the new Catholic Church of the Sacred Heart, offering

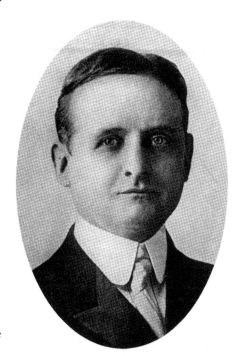

John F. "Honey Fitz" Fitzgerald, son of Irish immigrants and grandfather of President John F. Kennedy, who lived at 4 Garden Court off North Square. It was here that his daughter, Rose, mother of the future president, was born in 1890.

services in the Italian language. The building had been acquired in 1884 by Italian immigrants, members of the Society of St. Marks. Because the Irish-dominated Boston Catholic hierarchy was cool to the idea of establishing ethnic churches, the inauguration of this parish was delayed until 1888, when Reverend Francesco Zaboglio of the Scalabrinian Order arrived from Italy to take charge. From this point on, however, the parish flourished. In 1900, the old church was extensively remodeled. A parochial school was built on an adjacent parcel in 1902 and a rectory was acquired in 1923.

Prejudice against Italians ran as strong as that which had earlier been directed against the Irish. Some sense of the depth of the hostility is gained from the following description of North Square appearing in Samuel Adams Drake's 1906 guide book, *Old Landmarks and Historic Personages of Boston*:

> *Nowhere in Boston has Father Time wrought such ruthless changes, as in this once highly respectable quarter, now swarming with Italians in every dirty nook and corner. In truth, it is hard to believe the evidence of our own senses, though the fumes of garlic are sufficiently convincing. Past and present confront each other here with a stare of blank amazement, in the humble Revere homestead, on the one side, and the pretentious Hotel Italy on the other; nor do those among us, who recall something of its vanished*

prestige, feel at all at home in a place where our own mother-tongue no longer serves us.

Would that Samuel Adams Drake and others who viciously disparaged North Square and its immigrant residents at the turn of the century could be brought back to see the highly desirable and cosmopolitan neighborhood that it has become in our day.

Unfashionable Beacon Hill

There is no more fashionable address in Boston today than Beacon Hill, but such has not always been the case. Prior to the late eighteenth century, the triple-peaked ridge that ran across the northwestern end of the town, the "Trimountain" (as Beacon Hill was called originally), was decidedly the wrong end of town.

Oceangoing trade was the primary focus of Boston's economic life during the first century and a half of the city's history. Confined to a narrow and hilly peninsula comprising less than eight hundred acres, and thus ill-suited to farming, Boston's manifest advantages for trade included the finest harbor in southern New England, as well as a central location on Massachusetts Bay.

As Boston historian Walter Muir Whitehill wrote in his classic *Boston: A Topographical History*, prior to the early nineteenth century, Boston's main thoroughfare was State Street (called King Street before the Revolution), which led to its most important docking facility, Long Wharf. Here lay the true heart of Boston. "This broad half mile," Whitehill declared, "was the obvious avenue to Boston from the part of the world that really mattered"—its busy waterfront crowded with wharves, warehouses, and sailing vessels, and the distant commercial markets beyond the seas upon which the port city depended for its economic health.

Beacon Hill and its environs, by contrast, formed a remote and somewhat forbidding backdrop to the throbbing mercantile village of Boston. Still very much a walking city in the eighteenth century, Boston's residents typically lived quite near their places of employment. Even the wealthiest merchants and ship owners preferred living adjacent to their stores and warehouses.

The first street constructed on Beacon Hill, Sentry Lane (now Park Street), was put through in 1640 to give access to the sentry or beacon that had been erected in 1635 atop the Trimountain to warn the town of the approach of danger. Because of the remoteness of the location of Sentry Lane and public ownership of the land over which it passed (a part of the Boston Common),

the town fathers decided to locate a number of relatively unpleasant public institutions there, including the town's poorhouse, workhouse, jail, public granary and animal pound.

This concentration of disreputable public facilities on the eastern slope of Beacon Hill greatly diminished the neighborhood's desirability for residential development.

The first institution built on Sentry Lane, the town almshouse or poorhouse, a refuge for all categories of indigent Bostonians, including minor lawbreakers, was erected in 1662 at the upper end of Park Street, at the corner of Beacon. Destroyed by fire in 1682, the two-story gambrel-roofed edifice was immediately reconstructed on a larger scale.

Boston's Puritan fathers did an effective job of policing the town's poor, an element that was growing by leaps and bounds in the depression-ridden mid-eighteenth century. A 1740 description tells us that there were about a hundred poor people living at the almshouse, and that, despite widespread poverty, there was "no such thing to be seen in town as a strolling beggar…and a rare thing to meet with any drunken people, or to hear an oath sworn in the streets."

Next came the bridewell, or town jail, which was built just below the almshouse in 1720. This facility was intended for the accommodation of "able-bodied persons, who were unwilling to work, the almshouse never having been intended for such scandalous persons." The brick structure, which measured fifty feet long by twenty feet wide, was separated into three parts—a common room at the center, with wings at either end, one for the accommodation of the male prisoners, the other for the female prisoners.

In the same year, 1720, the town pound was moved to a site just below the bridewell. Here were temporarily housed horses, cattle, sheep, hogs, goats or

The Park Street, lower Beacon Street and Tremont Street areas in 1722. The almshouse and the bridewell (town jail) are visible in the upper left-hand corner of this illustration.

other trespassing livestock, with the owners of these errant beasts having to pay a fine upon reclaiming their property.

In 1736, a workhouse was added to this growing complex of institutional buildings. The workhouse, intended for the use of "idle and vagabond persons, rogues, and tramps," was erected just below the jail, on a parcel bordering the Granary Burying Ground (the third oldest burying ground in Boston, dating from 1660).

The problem in Boston in the mid-eighteenth century was not so much one of able-bodied residents being unwilling to work as it was a shortage of available jobs. Refusing to acknowledge that the depressed economy of the time was generating unemployment, the town fathers took an increasingly harder line with the jobless. If one could not find employment, incarceration in the workhouse was the obvious solution.

The workhouse was a large 120-foot-long, two-story, gambrel-roofed brick building. The most common work carried on there consisted of picking oakum (for rope making) and the carding and spinning of wool, flax and yarn.

At the foot of the hill, at the corner of Tremont Street and Sentry Lane (on the site of the present Park Street Church), stood still another public institution, the town granary, which was constructed at the location in 1737. This wooden structure served as a storage facility for wheat, rye and corn, from which the city's poorer classes could purchase small quantities at reasonable prices. The granary served as a hedge against public food riots, a serious problem in urban centers in the eighteenth century. The granary was the largest building in Boston at the time, having a storage capacity of twelve thousand bushels.

This cluster of institutional structures, with the triple-peaked Trimountain as a backdrop, formed, as Nathaniel Shurtleff noted in his *Description of Boston* (1872), "the dreary part of the old town before the 1790s, a quarter that had scant attraction for prospective home builders."

In the 1730s, for example, when the ailing merchant Thomas Hancock, acting on the advice of his physician, decided to build a mansion up on Beacon Hill (just west of the present statehouse), his socially conscious wife Lydia made him promise that they would move back into town just as soon as his health improved.

The Hancock Mansion was the first substantial residence to be built on the eastern slope of Beacon Hill above the common. Hancock, Boston's richest merchant, built this imposing hewn-stone Georgian-style edifice in 1737. Later it served as the residence of Thomas's nephew and heir, John Hancock, the first governor of Massachusetts. Despite its elegance and the

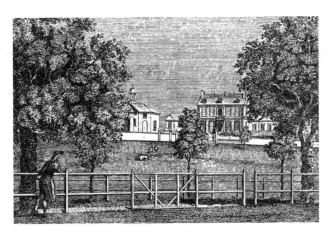

The Hancock Mansion was constructed on Beacon Street in 1737 for Boston's wealthiest merchant, Thomas Hancock, uncle of John Hancock. Not even the construction of this elaborate mansion, however, sufficed to make Eighteenth Beacon Hill a fashionable neighborhood.

excellent view its residents enjoyed, the building of the Hancock Mansion did not lead to the rapid development of Beacon Hill.

As late as the 1780s, only a handful of houses stood on Beacon Street— none comparable in scale to the Hancock Mansion—the most notable being the home of the great painter John Singleton Copley, located on the site of the present Somerset Club at 42 Beacon Street. Copley acquired his house and eighteen acres of land at the time of his marriage in 1769, becoming by this purchase the principal landowner on the hill. The very thing that discouraged others from locating on Beacon Hill, the remoteness and rural character of the neighborhood, may actually have served to recommend the site to Boston's foremost artist.

Not until the decade of the 1790s, in the context of renewed economic growth and a rapidly increasing population, would the Mount Vernon Proprietors and Charles Bulfinch, the great architect who designed the statehouse, begin to transform Beacon Hill into Boston's most fashionable neighborhood. By the end of the first decade of the nineteenth century, the various public institutions that had once lined Sentry Lane (to the manifest injury of the neighborhood) had been relocated, and Beacon Hill was well on its way to becoming Boston's premier elite neighborhood.

The Rise and Fall of Fort Hill

The tiny Shawmut peninsula, on which the town of Boston was founded in 1630, was dotted with hills. The remnants of the Trimountain, present-day Beacon Hill, remind us of the time when a triple-peaked ridge ran across the northwestern edge of the peninsula. Another of these

elevations, Copp's Hill in the North End, site of the city's second oldest burying ground, has survived the centuries virtually intact. Only one of Boston's larger promontories, Fort Hill, has completely disappeared, not only physically, but from our collective memory.

What gives Fort Hill particular historical importance is the role it long played as Boston's primary defensive bastion, for this elevation stood on the very edge of the harbor, a hillock jutting out between the two large coves (Great Cove and South Cove) that indented the waterfront in the early years. Fort Hill stood about where International Place stands today.

The contours of Fort Hill were admirably suited for defense. While the side that faced the harbor was lined with rugged bluffs, which any enemy would find extremely hard to scale, the inward-facing side sloped gently toward the center of town, giving the inhabitants easy access to its heights.

In 1634, William Wood, author of *New England's Prospect*, described the eighty-foot-high Fort Hill as "a great broad hill, whereupon is planted a fort [built in 1632] which can command any ship as she sails into the harbor." The hill's strategic importance was enhanced in 1666 by the construction of an even more elaborate fortification, the South Battery, at the foot of the hill on the waterfront, on the site now occupied by Rowe's Wharf.

Attack from the sea was a real possibility in the colonial period, when the mother country was fighting a series of wars with her imperial rivals—Spain, the Netherlands and France. As the most important mercantile center in British North America, Boston was in more or less continuous danger of attack. This was true even in the Revolutionary era, when Britain herself became the enemy. One of the first things General Washington did upon occupying Boston after the British evacuation of March 1776 was to order Fort Hill's defenses reinforced.

While no attack upon Boston ever came (the hill would perhaps still exist as a battle park if it had), other events of historical importance transpired there that deserve to be remembered.

The most noteworthy event of the colonial period occurred in 1689, when the highly unpopular Royal Governor Sir Edmund Andros installed himself in the fort after word reached him of the fall from power of his patron, King James II, hoping thereby to avoid arrest and deportation to England. The governor was also counting upon the support of a British frigate then anchored in the harbor.

The people of Boston, who detested Andros and wanted nothing so much as to send him packing, responded to this crisis with characteristic energy. First, the town's training bands (militia companies) were summoned by a beating of drums. Then the captain of the British frigate, who happened to

be ashore at the time, was arrested to ensure the warship's good behavior. Finally, the militia seized control of the South Battery, turned its guns upon the governor's hilltop refuge, and threatened to blow him sky high should he refuse to surrender. Andros had little choice but to comply, and was duly sent home to face the new monarchs, William and Mary.

Development on Fort Hill in the colonial period was almost exclusively commercial. By the 1720s, several wharves and shipyards ringed the Battery March at the foot of the hill. These included the Oliver, Whitehorne, Hubbard and Gibbs Wharves, and the Gale, Wing and Hollaway Shipyards. In addition, Captain Bonner's 1722 map of Boston shows that three ropewalks existed on the western side of the hill. As a trading center, Boston had a great need for cordage.

While many of these commercial structures suffered destruction in the Great Boston Fire of 1760, they were mostly rebuilt. In 1794, however, a second blaze again destroyed the ropewalks. This time they were not reconstructed. Instead they were moved to the western edge of the common. It was in the immediate aftermath of this 1794 fire that the neighborhood began to experience major residential development.

With the danger of attack from the sea greatly reduced after 1790, the hill ceased to have defensive value. The hilltop fort was taken down in 1797, and the site was given the name Washington Place. One contemporary described the location as "a pretty little park with a beautiful view over the harbor." The South Battery disappeared when the adjacent waterfront was extensively redesigned by Charles Bulfinch in 1804.

A short distance west of Washington Place lay Hutchinson Street (which was renamed Pearl Street in 1800). It was here that an elite residential neighborhood began to develop in the 1790s. Its earliest residents included

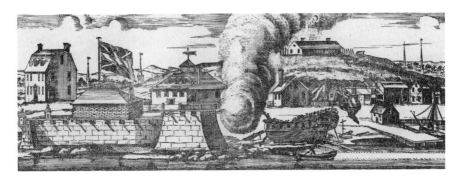

Here we see an illustration of Fort Hill as it appeared in the late colonial period. No other elevation in the city offered comparable defensive advantages.

such distinguished figures as Congressman (and future mayor) Josiah Quincy, the namesake of the Quincy Market, and the great China trade merchants, James and Thomas Handasyd Perkins. In 1808, a row of elegant townhouses was built on the perimeter of Washington Place. Quality residential development soon spread to the general area.

The neighborhood's elite character did not long survive, however. The departure of the Perkins brothers between 1822 and 1833 signaled the direction Fort Hill was taking. Elder brother James Perkins donated his Pearl Street home to the Boston Athenaeum in 1822 as a headquarters, while the younger brother, Thomas, turned his neighboring mansion—the most elaborate residence in Fort Hill—over to the school for the blind that Dr. Samuel Gridley Howe had founded in 1829, afterwards called the Perkins Institute for the Blind. The Perkins brothers built new residences in more fashionable areas of the city and many of their neighbors quickly followed suit. The institutions that the Perkins residences accommodated did not remain in Fort Hill for long, either. The school for the blind continued on Pearl Street for a mere six years before relocating in South Boston, while the athenaeum moved to its handsome new Beacon Street headquarters in 1849.

After 1840, the Fort Hill neighborhood suffered a rapid decline in social status owing to two other factors: first, the downtown was becoming more commercial, which generated noise and traffic; then, after 1845, huge numbers of impoverished Irish immigrants, victims of the devastating potato famine, moved into the area. As immigration historian Oscar Handlin has written, there were two parts of the downtown, both situated adjacent the city's wharves and factories, that were "logical receiving points for the Irish proletariat—the North End and Fort Hill."

The neighborhood's now mostly absentee owners, who wished to maximize the rental income from their properties, constructed hovels in every nook and cranny. By the mid-1850s, the once eminently respectable Fort Hill neighborhood had been transformed into a festering slum where incredible congestion, poor ventilation and the absence of adequate waste-disposal facilities and of indoor plumbing not only produced the city's highest mortality rates, but acted as a breeding ground for epidemic diseases that posed a serious health hazard to the population at large.

These conditions prompted the city to begin the systematic demolition of the Fort Hill neighborhood in 1866, the first major urban renewal project undertaken in Boston, culminating in the 1869–72 removal of the hill itself. By 1872, historic Fort Hill had passed into history.

Part II

Revolutionary Boston

The following columns deal with aspects of the Revolutionary period of Boston's history that I felt deserved to be better known.

"Points of Protest in Colonial Boston" was written as a by-product of a walking tour on that theme that the Bostonian Society asked me to lead some years ago. The column makes the crucial point that protests and disturbances had a long history in Boston, predating the Revolutionary era, and were often quite violent in character, and that they were as much a by-product of the economic difficulties the Hub was experiencing by the mid-1700s (as it slipped into a prolonged depression and large scale unemployment) as they were of its growing political dissatisfaction with British attempts to squeeze revenue out of the hard-pressed colony.

"John Singleton Copley's Dilemma" examines the deteriorating relationship between the people of Boston and Britain and its Loyalist clients, in the context of the career of America's preeminent painter, and analyzes the factors that led to Copley's 1774 self-imposed exile from his native city. Here my interest in Revolutionary Boston converged with another area of deep interest, the history of American art, a topic upon which I have lectured frequently.

"Watertown: Revolutionary Capital of Massachusetts" makes the important point that the function of Boston as the Massachusetts seat of government was transferred to Watertown during the period of the British occupation of the city, and for some months thereafter, and that this aspect of the history of the early Revolution has received too little attention.

"Defending the Charles" underscores the importance of the Charles River estuary and the little-appreciated fortifications along the Charles, particularly Fort Brookline, during the eleven-month-long siege of Boston.

Points of Protest in Colonial Boston

Political violence was a commonplace in Boston throughout the colonial era. The Hub was by no means unique in that respect. Rioting was an intrinsic element in the political culture of the time. But the resort to crowd demonstrations against unpopular beliefs, policies, persons and property was perhaps more prevalent here than anywhere else in Britain's North American colonies.

In an era when society was lacking in professional police forces to suppress such disturbances, there was little to prevent the public from manifesting its outrage over policies that impinged upon the liberties, livelihoods and safety of the multitude.

While riots often ranged widely over the face of the city, sometimes beginning at one end of town and ending at another, there were also certain logical focal points to these flare-ups. These included the Old State House at the head of King Street (now State Street), where the legislature met; the Old South Meetinghouse (the largest indoor space in colonial Boston);

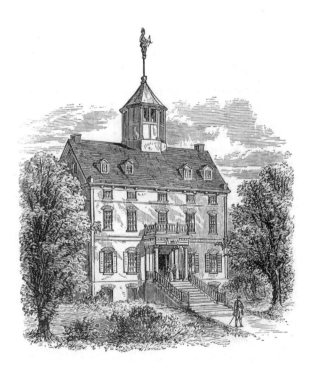

Province House, the official residence of the royal governors, was a focal point of protest during the Provincial era. This palatial mansion, built in 1676, and originally the home of Boston merchant Peter Sargent, was purchased by the colonial legislature in 1716 for the use of the royal governors. A mob, several thousand strong, attacked this building in 1747 to demand an end to the impressment of colonial sailors into the service of the Royal Navy.

the Province House (residence of the royal governors); King Street and the waterfront beyond (where the town's principal commercial establishments were located); the Boston Customs House on King Street, the headquarters of the hated commissioner of customs; Faneuil Hall (where Boston's town meetings were normally held); and North Square, in the North End, the so-called "Court End of Town," the place of residence of a number of the city's richest Tory merchants.

Crowd actions usually occurred at night, the participants preferring the anonymity provided by a cover of darkness. In addition, rioters often disguised themselves in order to avoid detection.

While the riots that have received the greatest attention from historians are those that occurred in the years just prior to the Revolution (most notably the Stamp Act riot of 1765; the disturbances leading to the March 1770 Boston Massacre; and the December 1773 Boston Tea Party), rioting was just as prevalent in earlier years. Moreover, these earlier riots offer valuable insights into the character of colonial society.

The mainsprings of colonial era rioting were diverse—religious prejudice, class antagonisms, economic grievances, public health disputes, anti-immigrant sentiment and opposition to British imperial policies.

The Puritan founders of Massachusetts feared and detested both the Anglican and Catholic Churches. They had come to America to escape the authority and influence of these detested creeds, which they considered to be corrupt. Latter-day Bostonians welcomed the opportunity to reaffirm their loyalty to the principles of their Puritan fathers.

Every November 5 (the anniversary of England's Gunpowder Plot), Bostonians gave vent to their anti-Catholic sentiments. Turn-of-the-century historian Samuel Adams Drake described these so-called "Pope's Day" observations, which often led to broken bones and bloody noses, as a virtual "saturnalia."

A lively rivalry existed between the two principal neighborhoods of colonial Boston, the North and South Ends (the latter then situated in the present commercial district). This rivalry reached high intensity on Pope's Day, when each section organized a procession to reaffirm its loyalty to Protestantism.

As Drake noted of these demonstrations: "Each section had its procession and its [papal effigy], and when the rival parties met at the mill creek bridge [on the line of present-day Blackstone Street], a battle ensued with fists, sticks, and stones, and one or the other of the popes was captured."

If the North End prevailed, the rival neighborhood's pope would then be burned atop Copp's Hill; if the South End triumphed, the honors were

performed on the Boston Common. These Pope's Day melees continued until 1775, when General George Washington ordered their termination on the grounds that they were an offense to the Catholic French, who we were then looking to for support in our war with Britain.

Rioting stemming from economic grievances was a frequent occurrence between 1689 and 1759, when Britain and her colonials were fighting the French for control of North America. The long and exhausting conflict (the so-called French Wars) disrupted the traditional lines of New England trade and led to higher taxes and runaway inflation. Nowhere were the effects more powerfully felt than in Boston. Other by-products of the French Wars included unemployment, a substantial increase in the number of dependent poor and a reduction of the purchasing power of the city's lower classes.

By the mid-1740s, Boston's economy had been so thoroughly dislocated that one in four of the city's residents was living below the subsistence level. Economic conditions here, incidentally, were worse because Boston lacked an agriculturally rich hinterland such as existed outside of New York, Philadelphia and Charleston.

Major riots of the early 1700s included the following circumstances.

In the period 1708 to 1711, angry mobs attacked the ships and warehouses of Jonathan Belcher, a grasping merchant who insisted on exporting grain and other scarce commodities to distant ports at a time when the city's population was suffering from serious food shortages.

Public disturbances also broke out in 1729 in opposition to the landing of diseased Irish immigrants. Public health issues generated much anxiety in an era of frequent epidemics, and Boston, which had the most ethnically homogenous population of any American city of the period, was less well disposed toward immigrants than other ports of entry.

In 1737, Boston's public markets were attacked and destroyed by a mob (disguised in this instance as clergymen) as a protest against the requirement that food be sold only in officially sanctioned locations, the people believing that the city's merchants could more easily manipulate prices if such marketplaces existed. Resistance to the establishment of public markets was longstanding. Even in the early 1740s, when wealthy merchant Peter Faneuil offered to build a market house at his own expense, Boston's electors approved the proposal only by a razor-thin margin of 7 votes out of 727.

The most serious instance of crowd action in the entire colonial period occurred in November 1747, toward the end of the third French War (King George's War), when the British navy sent a press gang into Boston to round up stray merchant seamen for forced service in His Majesty's navy. In all, the press gang snared fifty Boston sailors.

In this November 1747 Impressment Riot, Bostonians attacked and drove off the press gang, liberating the sailors. The angry mob then took into custody every Royal Naval officer it could lay its hands on and marched them to the residence of Royal Governor William Shirley, demanding that the press gang cease its activities. When the sheriff and his deputies attempted to intervene to disperse the assembled protesters, the mob attacked and drove off the officials. Governor Shirley next directed the militia "to suppress the mob by force," but the colonial militiamen showed little disposition to obey. The rioters, now estimated at several thousand, reacted to this attempt at suppression by stoning the Province House and breaking in all of its windows. They then surged on to Boston's waterfront and seized and burned a twenty-gun vessel that was then under construction for the Royal Navy.

One historian has labeled the 1747 Impressment Riot, an event which occurred more than a quarter of a century before the outbreak of the American Revolution, as "the most massive civil disobedience in Boston's history."

John Singleton Copley's Dilemma

One of the most regrettable consequences of the coming of the American Revolution was the permanent departure from Boston in June of 1774 of the great painter John Singleton Copley. Copley produced hundreds of magnificent portraits of prominent Americans between 1753 and 1774. His departure from the Hub left an artistic void that long remained unfilled.

What factors prompted this great native genius—the preeminent American painter of his day—to abandon the city of his birth on the eve of the American Revolution?

Born in 1738, the son of recently arrived Irish Protestant immigrants, John Singleton Copley was raised in cramped quarters over the family's tobacco shop on Boston's Long Wharf. The future painter's father, Richard Copley, died when his son was quite young.

In 1748, when John was ten, Jane Singleton Copley married Peter Pelham, an English-born engraver, whereupon mother and son moved to Pelham's residence on Lindall Row (just off present-day Congress Street). Here the youth received his first instruction in painting. Pelham was a close associate of the leading Boston portraitist of the day, John Smibert, the first academically trained painter to settle in America. Smibert's studio and art supply business was at the heart of the local art world. Peter Pelham frequently made engravings of Smibert's portraits for sale to the general

public. Copley's exposure to these important Boston artists, while critical to his training, was short-lived, for both died in 1751, when the boy was just thirteen.

Ambitious and highly talented, young Copley continued to hone his natural abilities after the demise of these teachers, drawing upon his late stepfather's books and engravings and upon the works and plaster casts that were still on exhibit in Smibert's studio.

In 1753, when only fifteen, Copley executed his first recorded commission, a portrait of Mrs. Joseph Mann, a tavern keeper's wife. His career was launched at a propitious moment, for Boston's leading painters, Robert Feke and John Greenwood, had recently left the city. By the time another trained painter, Joseph Blackburn, arrived in 1755, Copley's skills had developed to a point that he could compete with the more experienced newcomer. When Blackburn left Boston eight years later, Copley moved into the commanding position in the Boston art world that he would occupy until his own departure in 1774.

Copley became the favorite painter of the city's elite families. No upper-class Boston home of the period was regarded as being properly furnished without one or more Copley canvasses hanging on its walls.

And it little mattered on what side of the developing political divide the sitter stood. Everyone wanted to be painted by Copley and the painter played no favorites. His subjects included the principal Patriot leaders of the day— James Otis, Sam Adams, Paul Revere, John Hancock, Richard Dana, Josiah Quincy and Joseph Warren—as well as the leading Tories—William Brattle, Isaac Royall, Benjamin Hallowell, Francis Bernard, Thomas Hutchinson, and Andrew Oliver.

The popularity of Copley's paintings stemmed from two factors chiefly: their faithful realism and his extraordinary gifts as a colorist. He was particularly adept at painting the rich backgrounds that celebrated the material wealth and social prominence of his subjects. The merchants and other men of affairs who commissioned these portraits wanted, above all, to be recognized for their power and prosperity, and Copley's canvasses gave them exactly what they craved.

Copley desired to be recognized beyond the confines of Boston and the American colonies. As early as 1766, he sent a painting of his half-brother, Henry Pelham, entitled *Boy with a Squirrel*, to England to be exhibited at the London Society of Artists. This handsome canvass elicited much praise. Sir Joshua Reynolds, the leading British painter of the day, proclaimed it "a very wonderful performance," and Copley was immediately elected to the Society of Artists of Great Britain. Both Reynolds and the Benjamin West

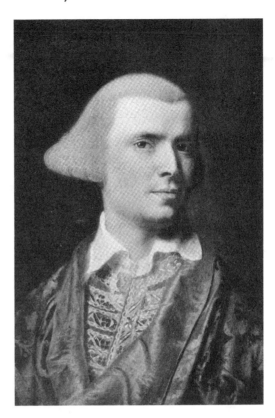

A self-portrait of John Singleton Copley, Boston's most celebrated painter, made shortly after his marriage into the Loyalist Clarke family in 1769.

(an American who had already achieved notable success in England) urged Copley to abandon Boston and to settle in London, where his talents would be both better appreciated and more properly developed. Reynolds declared that Copley would be "one of the first painters of the world provided he came to London before his manner and taste were fixed by working in [his] little ways in Boston."

In the meantime, however, Copley had attained the pinnacle of social and economic success here in Boston. Two events of 1769 reflected this rapid rise. First came his marriage to Susannah Farnham Clarke, the daughter of Richard Clarke (a nephew of Royal Governor Thomas Hutchinson), one of Boston's great merchants.

The second indication of success was Copley's purchase of an eighteen-acre estate on Beacon Hill. This property, Mount Pleasant, situated just west of Walnut Street and extending back to the site of present-day Louisburg Square, provided the artist with a pleasant rural setting in which to paint, at a distance from the hustle and bustle of the downtown. The property contained three houses, a barn and an orchard. Copley remodeled one of

these houses (on the site of 42 Beacon Street) into a showplace residence. John and Susannah moved into this refurbished mansion in 1772.

Copley's marriage into the Clarke family marked a major turning point in his career. Until then, he had always taken a neutral stance on the issues that divided Boston. Now, he was allied to the House of Clarke—a family of Loyalists that was growing increasingly unpopular with the multitude.

In late 1773, the firm of Richard Clarke & Sons was appointed one of the five consignees for a cargo of British East India Company tea then on its way to Boston—a cargo which the Sons of Liberty were determined to turn back.

An attack on the Clarke Mansion in early November 1773 foreshadowed Copley's emerging dilemma. A mob hurled sticks and stones at his in-law's elegant School Street residence for over an hour, shattering every window in the house.

Then, on November 30, Copley made the fateful error of intervening personally in the tea dispute by addressing a Boston town meeting at the Old South Meetinghouse. He urged the people of Boston to allow his in-laws, who had fled to Castle Island in the harbor, an opportunity to explain their position on the tea issue. While the town agreed to hear the Clarkes, Copley was unable to persuade them to leave the safety of Castle Island. He did, however, bring back a pledge from the tea consignees that no immediate attempt would be made to land the offensive commodity, whereupon the townspeople adjourned without taking action.

Copley played no further role in the tea controversy, which culminated, of course, in the famous Boston Tea Party of December 16, 1773, leading, in turn, to the Intolerable Acts, and subsequently to the outbreak of the Revolution.

There can be little question that Copley's November 30, 1773 appeal in behalf of his Loyalist in-laws fatally undermined his position in Boston, for he was thereafter widely perceived as a Tory sympathizer. He personally became a target of mob action in April 1774, when angry Patriots converged on his Beacon Hill residence, demanding that he turn over to them Colonel George Walton, a house guest, who was about to be sworn in as a royal commissioner.

Copley's departure for England in June 1774 was thus the product of a convergence of factors: his mounting concern for the safety of his family, a decline in the demand for his services as a painter (owing partly to his identification with the Loyalist element and partly to the sorry state of the Boston economy) and his long-standing desire to test himself in the broader context of the British art world.

Watertown:
Revolutionary Capital of Massachusetts

When one thinks of Massachusetts in the Revolutionary period, the locations that come most readily to mind are Boston, the towns of Lexington and Concord and the Battle Road along which the badly mauled British marched back whence they came. Less well known, but equally important as a center of Revolutionary activity, was Watertown, which served as Massachusetts's capital during the most active stages of that struggle.

The Coercive Acts, adopted by parliament to punish Boston for its December 16, 1773 Tea Party, closed the port of the offending capital and ordered the legislature, or General Court, to convene in Salem.

The day after the General Court assembled in Salem in October, 1774, its members took two decisive steps. First, they transformed the legislative branch of the government into a self-sufficient Provincial Congress, and then relocated this extralegal body to the safer interior town of Concord, which the legislature had also designated as a collection point for the stockpiling of arms and ammunition. Thus Concord became the target of the April 19, 1775 British expedition that precipitated the American Revolution.

Three days after the Battles of Lexington and Concord, however, the seat of Massachusetts government was relocated once again, this time to the more easterly community of Watertown, which lay very near the army's headquarters in neighboring Cambridge. Massachusetts's seat of government was to remain in Watertown for the next eighteen months—from April 22, 1775, to November 9, 1776.

A prosperous farming and cattle-raising town of about eight hundred residents, Watertown lay at the western end of the Charles River tidal basin, some nine miles outside of Boston. It was chosen as the seat of government not only because of its proximity to the army, but also because Watertown was a crossroads, a point where several important highways converged, and where a bridge spanned the Charles River. The town had in fact long been a gateway to the interior of Massachusetts. A set of rapids obliged river-borne craft to unload passengers and cargo at Watertown. Because of its importance as a transportation nexus, Watertown contained several inns for the convenience of the 250 delegates to the Provincial Congress.

The Provincial Congress met in the Watertown Meetinghouse, which stood at the northeast corner of Common and Mount Auburn Streets in what is now the Common Street Cemetery.

The Watertown Meetinghouse, seat of the Massachusetts legislature from April 22, 1775, to November 9, 1776. The structure, which no longer stands, was located at the intersection of Common and Mount Auburn Streets, in what is now the Common Street Cemetery.

This rather large building, which measured fifty-six by fifty-two feet square, included a fourteen-foot bell tower at its western end. On the eastern end, a fourteen-foot porch led to a gallery where visitors could observe the legislature in session. Two men presided over the Massachusetts legislature during its time in Watertown—Dr. Joseph Warren of Boston (who held office until his tragic death at Bunker Hill on June 17, 1775) and, subsequently, James Warren of Plymouth.

In May 1775, the Provincial Congress took the fateful step of formally deposing Royal Governor Thomas Gage on the grounds that the king's representative had "disqualified himself to serve this colony as a governor, [and thus] no obedience ought to be paid him by the several towns and districts in this colony, [and] that he ought to be [regarded] as an unnatural and inveterate enemy" of Massachusetts.

No legislature in the history of Massachusetts has made more significant decisions than did this Watertown body. The measures it undertook included the recruitment of thirteen thousand men to support the rebellion; negotiation with various native peoples for their military support; and countless measures to secure supplies of food, weapons and clothing for the army that had the British cooped up in Boston.

Despite its insurgency, the Provincial Congress was not yet prepared to declare outright independence from Britain. Even the most rebellious of the congress's enactments were prefaced with the declaration, "In the 15th year of the reign of George III," and its sessions always began with an offering of prayers for the health of the British monarch and his family. These anachronous expressions of loyalty continued for more than a year, being abandoned only in May 1776.

On July 2, 1775, George Washington, designated by the Continental Congress as commander-in-chief of the army, was formally received by the Provincial Congress in Watertown.

In mid-July, at the urging of the Continental Congress, Massachusetts adopted a new frame of government based loosely on the Royal Charter of 1691. Rather than reestablish the office of governor, however, a council was instituted to exercise the executive function on a collective basis. At this point, the legislature also resumed calling itself the "Great and General Court."

The Fowle House, now on Watertown's Marshall Street, where the executive branch of Massachusetts government met during the period in which Watertown served as the Revolutionary capital of Massachusetts.

While the Watertown Meetinghouse—the scene of so many key events of the Revolutionary era—has disappeared, another important Watertown Revolutionary landmark survives. The Fowle House, which stood originally on Mount Auburn Street, adjacent to the meetinghouse (it was relocated to nearby Marshall Street in the late nineteenth century), must surely rank as one of the most significant buildings in the state, yet it is little known outside of Watertown.

The council and the various committees of the legislature convened on the second floor of this building, while the legislature's presiding officer, James Warren, and his well-known wife, the writer Mercy Otis Warren, as well as Mercy's famous brother, the somewhat-addled Patriot leader James Otis, resided on the ground floor of the historic edifice. Many of the leading men of the Revolutionary era visited the Fowle House, including George Washington, Benjamin Franklin and Elbridge Gerry.

Another important but lost Watertown Revolutionary landmark was the Cook House, which stood near the corner of Galen and Watertown Streets, just south of the Charles River. Here Paul Revere lived with his wife and six of his many children for more than a year. While a resident of Watertown, Revere was mostly occupied producing currency for the Provincial government. The plates he engraved for Massachusetts paper money were considered so important that the congress ordered them kept under continuous military guard.

Also occupying the Cook House for a time was Benjamin Edes, publisher of the *Boston Gazette*, the mouthpiece of Boston's Sons of Liberty. Fleeing the port city in late April 1775, this Patriot editor transported his type and printing press to Watertown by boat via the Charles River under cover of darkness. There he resumed its publication, while also serving as printer to the Revolutionary government.

Henry Knox, the Boston bookseller and amateur military strategist likewise resided at the Cook House for some time. Knox, who was eventually given command of the artillery of the Continental army, is best remembered, of course, for transporting the cannon from Fort Ticonderoga that forced the British out of Boston on March 17, 1776.

So many Bostonians resided in Watertown during the eleven-month-long siege of Boston that Boston's town meetings were actually held in Watertown. In addition, some of Boston's religious congregations conducted worship services there, services that reputedly opened with a psalm that ran: "By the rivers o Watertown we sat down and wept When we remember thee O Boston."

One of the most dramatic episodes of the period was the November 1775 trial for treason of Dr. Benjamin Church, a high official of the Revolutionary government. Church was first court-martialed by a military tribunal in Cambridge, which stripped him of his military rank, and then by

the legislature in Watertown, which deprived him of his seat in the General Court and his other political offices.

Clearly Watertown played a central role in the history of the Revolutionary period that deserves to be more widely celebrated.

Defending the Charles

After the April 19, 1775 Battles of Lexington and Concord, and the headlong retreat of the badly mauled British into Boston, the greatest challenge facing Patriot forces was to keep the detested lobsterbacks and their powerful naval squadron confined in the city until sufficient artillery could be secured to force them out altogether.

With that objective in mind, the Patriots constructed an encircling system of redoubts, batteries and forts. This hastily built ring of earthen works extended from Roxbury to the southwest of Boston, through Cambridge, Somerville and Medford, to the northwest. This proved a highly effective stratagem, giving rise to the famous eleven-month-long Siege of Boston.

The most vulnerable point on the American defensive perimeter was, without doubt, the Charles River Basin, a nine-mile-long natural highway into the interior. If the British naval squadron could freely access this waterway, it would be in a position to offer critical support to its ground forces assaulting the American lines.

The defense of the Charles River Basin was made all the more important by the role that two of its towns, Cambridge and Watertown, were playing in the Revolutionary drama—the former, as the headquarters of the Army of New England, and the latter, as the headquarters of the Revolutionary government.

The largest of all the entrenchments constructed by the American army was Fort Brookline, which stood just west of the present Boston University campus, about where the Boston University Bridge crosses the river today.

Sewall's Point, as this location was then called, had several defensive advantages. Its elevated location gave it a clear view of approaching enemy forces. The location was also surrounded on three sides by the Charles and its tidal marshes, rendering it easy to defend. Most importantly, Fort Brookline stood just west of the point where the Charles widened dramatically into the Back Bay (then, of course, still under water). Any British warship venturing into the lower reaches of the Charles would thus be within range of the six four-pound cannons the Americans mounted at Fort Brookline, making a seaborne assault on the American lines potentially disastrous.

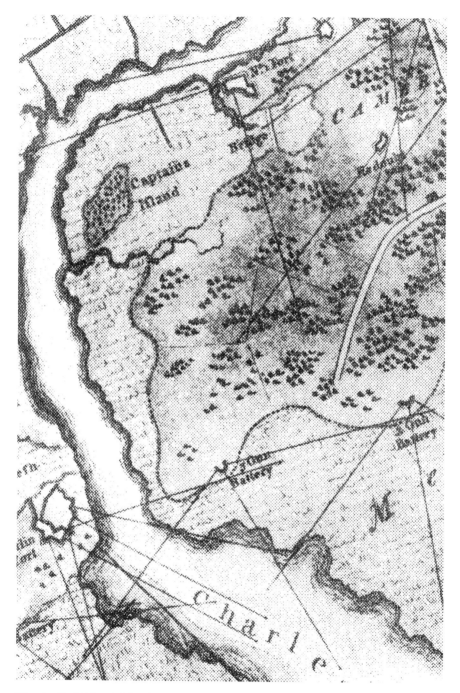

This detail of *Pelham's Map of 1777* shows the principal Revolutionary War fortifications on the Charles River Basin. Fort Brookline at Sewall's Point appears at the lower left-hand corner.

Revolutionary Boston

The construction of the various fortifications on the edge of the Charles became all the more critical after the British pushed the Americans off of the Charlestown Peninsula in the June 17, 1775 Battle of Bunker Hill.

Colonel Rufus Putnam, who was placed in charge of the construction of all the fortifications south of the river, designed Fort Brookline as well as the two neighboring redoubts to the southeast. These entrenchments and the marshy character of the ground east of the fort, including an extensive cedar swamp, made a direct overland attack on the south bank of the Charles impractical.

The first portion of Fort Brookline to rise was a redoubt facing east toward Boston. Breastworks were soon added on either side of this structure. Large-scale construction began on July 10, when Colonel Oliver Prescott's 430-man Middlesex County Regiment was sent to assist in building the fort. Later in the month, Prescott's force was transferred to Cambridge, to be replaced by a 498-man regiment under the command of Colonel Samuel Gerrish of Newbury, Massachusetts, a controversial figure who had given a rather mediocre account of himself at Bunker Hill.

The building of this giant earthen-work fort required an estimated twenty thousand manhours of labor and took about six months to complete. Measuring some 600 by 470 feet, it covered almost six acres of ground.

Other fortifications near the Charles River Basin were far more modest in size. The best known of these, owing to the survival of a portion of its earthen works, is Cambridgeport's historic Fort Washington, which was restored in 1858, and now serves as a city park. Though the site lies some distance north of the river (near the intersection of Allston and Waverly Streets), in Revolutionary times this battery sat on a rise of land on the very edge of the tidal river.

A few hundred yards north of Fort Washington, a similar entrenchment was constructed, also on the edge of the tidal marshes, overlooking an indentation in the shoreline called Little Cove.

About half a mile west of these batteries, closer to the village of Cambridge, stood two somewhat more substantial entrenchments known as Forts Nos. 1 and 2, the former located near the intersection of present-day River Street and Putnam Avenue, the latter at Putnam Avenue and Franklin Street.

As historian Richard Frothingham wrote in 1873 of the remains of these Revolutionary entrenchments:

> *The forts and batteries of this line of defense, which constituted the firmest bulwark of the American army, are* [today] *all leveled with the ground, and the entrenchments which were raised and defended by warriors are now employed in the peaceful pursuits of agriculture.*

A century and a half later, the agricultural pursuits Frothingham referred to have given way to a variety of commercial, industrial and recreational activities. The site of Fort No. 1 today, for example, accommodates Riverside Park, formerly the location of the Riverside Press, and before that, of the old Cambridge almshouse.

The American fortifications on the Charles were assaulted by the British on July 31, 1775, some six weeks after the Battle of Bunker Hill. Following a heavy bombardment of the American lines south of the city, British forces advanced into Roxbury, but found that village deserted. After setting fire to several of its structures, the king's troops withdrew into Boston.

A second assault had meanwhile been launched against the American lines in the eastern part of Cambridge. Here the defenders were initially repulsed, but with the arrival of reinforcements from Cambridge, they were able to reassert themselves, killing several of the British attackers and driving them back toward Charlestown.

The third and most important assault was launched against Fort Brookline itself, then still in the early stages of construction. The British understood the strategic importance of the site, and hoped a vigorous bombardment would scare the inexperienced Americans out of the unfinished fort. With that goal, they rowed two floating batteries (each containing six twenty-four-pound cannons) to within three hundred yards of the fort. It was late in the day before they reached the desired position and opened fire.

Fortunately, the Americans did not panic. Instead they pursued the passive strategy of lowering their heads and sitting out the British cannonade. "The rascals can do no harm," Colonel Gerrish declared in ordering his men not to respond, "and it would be a mere waste of powder to fire at them with our four-pounders." As Frothingham wrote of this engagement, "It was evening, the lights were extinguished, and all the British balls flew wide of the fort. After several hours of ineffectual firing, the British abandoned the effort and withdrew their floating batteries from the basin."

Colonel Gerrish's passive defense of Fort Brookline did not meet with official approval, however. It had the effect of destroying his military career. Following the British withdrawal, General Washington, who believed that Fort Brookline's cannons could have done the enemy serious damage, ordered Gerrish placed under arrest. The unfortunate colonel was subsequently found guilty of "conduct unworthy of an officer" and was dismissed from the American service.

Part III

The Athens of America

It was William Tudor, a Bostonian with literary aspirations as well as much business foresight, who in 1819 dubbed Boston "the Athens of America" in celebration of the role the Hub was already playing as the nation's principal cultural fountainhead.

Interestingly, Tudor was also an incorporator of the Granite Railway, the pioneer American industrial railroad that launched "Boston's Age of Granite," that being the topic of the first column appearing below. Another of these pieces describes the construction of the Boston & Roxbury Mill Dam, a project that marked the first step in the filling of the Back Bay, and that provided the city with a direct link to its western hinterland.

Another of these columns focuses upon the fierce resistance of Boston's "men of property and standing" to the moral suasion message of William Lloyd Garrison, the leading radical abolitionist of the day, to the point of threatening to hang that nonviolent firebrand from a tree in the Boston Common.

The remaining four columns deal with such diverse topics as the singularly enthusiastic reception given the Marquis de Lafayette when he visited Boston in 1824 (incidentally, following the appearance of this article in 2002, I was invited by the Lafayette Society of Massachusetts to speak at a luncheon in honor of the Count and Countess Lafayette, who were then visiting Boston); the activities of the wealthy and eccentric David Sears, who founded Brookline's elite Longwood neighborhood; the career of the major Boston horticulturalist Horace Gray who, in 1837, founded the Boston Public Garden; and one of the city's premier builders in stone, the highly prolific architect and engineer, Nathaniel J. Bradlee, designer of some five hundred Boston buildings.

Boston's Age of Granite

Boston contains the largest concentration of granite structures of any major American city. The extensive use of this attractive and durable stone in the Hub is easily explained, for the hills near Boston held a virtually inexhaustible supply of the stone. The use of this building material became so prevalent in the city's architecture by the mid-nineteenth century that historians sometimes refer to the period as "Boston's Age of Granite."

The major granite edifices constructed between 1820 and 1900 included most of the key public buildings of the time: the Boston Customs House, the Quincy Market complex, the Bunker Hill Monument, the Charlestown Navy Yard, Forts Independence and Warren in Boston Harbor, the Boston Athenaeum, the Old City Hall and the Charles Street and Charlestown Prisons, in addition to the city's major railroad terminals, post office, courthouse, major hotels, many of its landmark churches and most of the principal wharves and warehouses on the Boston and Charlestown waterfronts.

The first major granite building constructed in Boston was King's Chapel, erected in the mid-eighteenth century. Before the development of quarrying techniques in the early nineteenth century, however, the supply of granite was limited to the boulders that could be gathered from the fields of the surrounding countryside. So meager was this surface supply that the town of Braintree (of which granite-rich Quincy then formed a part), actually forbade the sale of the stone to outsiders, fearing that it might otherwise not be able to meet its own modest building needs.

The quarrying techniques introduced in the early 1800s, however, enabled stone men to begin extracting a virtually unlimited supply of granite from the hillsides near Boston. Once this ample supply became available, the number of granite structures in Boston and surrounding communities mushroomed.

However, another problem had to be overcome before Boston's Age of Granite would dawn in full force. The transportation problem had to be surmounted. The cartage of the heavy material was a slow, dangerous and expensive process. Ponderous ox- and horse-drawn carts were used to haul the large granite blocks along the roadways leading into Boston and these vehicles often bogged down in wet weather and sometimes collapsed under their weighty loads.

It was at this point that Gridley Bryant entered the picture. Born in Scituate, Massachusetts, in 1789, this largely self-taught engineer and contractor already had two major Boston-area building projects to his credit:

construction of the Roxbury Mill Dam across the Back Bay in 1821, and the Boston Branch of the Bank of the United States on State Street in 1823.

It was the construction of the Bunker Hill Monument in Charlestown that provided the incentive for the next major technological development in the granite industry. The Bunker Hill Monument Association had been chartered by the commonwealth in 1823 to build a monument to commemorate the great Revolutionary War battle. Soon afterwards, the association purchased a quarry in Quincy (aptly named the Bunker Hill Quarry) as a source of supply. In mid-1825, Gridley Bryant recommended that the association build a three-mile-long railway from this quarry to a specially constructed dock on the Neponset River, where the stone would be transferred to sailing vessels (steamboats were later employed) for shipment across Boston Harbor to Charlestown. The use of rails, Bryant pointed out, would reduce traction and so expedite and economize the movement of the heavy stone. While conceding that Bryant's proposal made good sense, the Monument Association nonetheless rejected it as too expensive for its own rather limited resources.

Fortunately Bryant's granite railway proposal received strong backing from another quarter. A number of well-to-do Boston businessmen (several of whom were also on the board of the Monument Association), men who recognized the long-term profit potential in the granite railway idea, decided to found a company to carry Bryant's railroad scheme to completion, acting under the leadership of the great Boston merchant Thomas Handasyd Perkins. On March 4, 1826, the Massachusetts legislature incorporated these gentlemen as the Granite Railway Company, with Perkins as president. Perkins, in fact, dominated the affairs of the company in its early years, owning twenty-eight of its original fifty shares. Other early stockholders included former Massachusetts Governor William Sullivan; David Moody, a founder of the Lowell textile industry; and leading manufacturer Amos Lawrence.

The Granite Railway, the first commercial railroad in the United States, was built between April 1 and October 7, 1826. Its tracks cost some $33,000, or about $11,000 per mile. The project as a whole, including the land, the great wharf built on the Neponset River, horses and equipment, cost some $100,000, a considerable sum in the 1820s.

The railroad portion of the route (comprising only about one quarter of the distance into the city) worked to perfection. A description of its inaugural run noted that "a quantity of stone weighing sixteen tons that was taken from the ledge belonging to the Bunker Hill Monument Association, and loaded on three [railroad cars], which together weighed five tons, making a

A largely self-taught engineer and contractor, Gridley Bryant persuaded the Bunker Hill Monument Association to build a three-mile horse-drawn railway from the organization's Quincy quarry to the banks of the Neponset River to expedite the transporting of heavy blocks of granite to the Bunker Hill Monument site in Charlestown.

load of twenty-one tons, was moved with ease by a single horse to the wharf on the Neponset River." However, cartage of the stone the remaining nine or so miles presented many difficulties.

The Granite Railway's first contract was signed on March 27, 1827, with the Bunker Hill Monument Association. Transferring the granite to vessels at the Neponset River dock, and again to wagons in Charlestown for hauling to the construction site, proved time-consuming and led to much grumbling on the part of the Monument Association's management. The architect of the Bunker Hill Monument, Solomon Willard, became so frustrated with the delays that he recommended cancellation of the railway's contract and a return to the traditional method of transporting the stone.

Adding to the Granite Railway's early difficulties was a growing use of huge monolithic granite elements in the design of public buildings, pieces of granite too large for the railway to handle. The best example is the Boston Customhouse, a building completed in 1838, the work of the distinguished architect Ammi B. Young. The twenty-two columns that surround this handsome Greek Revival building (which now forms the base of the Boston Customhouse Tower) each weigh an incredible forty-two tons. They were transported to Boston, not by the Granite Railway, but by a combination of horse- and ox-drawn wagons—some twelve teams of horses and sixty-five yokes of oxen being required to complete that formidable task.

Hauling granite over roadways by team was very difficult and expensive. Bryant's Granite Railway, illustrated here, reduced traction and expedited and economized the process of moving granite to Boston to meet the increasing demand for this handsome and durable building material.

Despite the difficulties the Granite Railway experienced in its early history, the system was eventually perfected and served to significantly increase the supply and reduce the cost of granite for Boston's architects and builders. The Granite Railway, which was in operation from 1827 to 1871, literally transformed the face of Boston.

So dominant did granite become as a building material in the city, the list of local architects who built in the material coincides with that of the greatest Boston area practitioners of that profession of the day—such eminent figures as Solomon Willard, Alexander Parris, Ammi B. Young, Isaiah Rogers, Edward Clarke Cabot, Nathaniel J. Bradlee and Gridley Fox Bryant, among others.

Interestingly, the last of these, Gridley Fox Bryant, whose buildings included the old Boston City Hall, the Boston City Hospital and Mercantile Wharf, was the son and namesake of the great engineer whose ingenuity led to the foundation of the Granite Railway.

Building the Mill Dam Road

One of the greatest engineering accomplishments of early nineteenth-century Boston was the construction, between 1818 and 1821, of a causeway

(the so-called Mill Dam) across the Back Bay. Prior to the building of this raised roadway, Beacon Street extended only as far as the foot of Charles Street, where the waters of the Back Bay impeded farther western progress.

However, the Boston & Roxbury Mill Dam, as this structure was originally known, was not conceived as a transportation project. The proposal was advanced with the object of fostering industrial development.

The individual chiefly responsible for building the Mill Dam was Uriah Cotting, merchant, real estate promoter and amateur engineer, who had already helped modernize a major part of Boston's waterfront. Boston historian Justin Winsor described Cotting as "the projector and guiding spirit in nearly every enterprise involving the development of the town for business during the first twenty years of the 19th century." Yet Cotting remains a somewhat shadowy figure.

It was during the War of 1812, at a time when industrial products were in short supply, that Cotting conceived a plan to harness the water power of the tidal Charles River for manufacturing. The plan called for the building of two dams, one on either side of the Boston Neck. The first would extend from the foot of Beacon Hill to Sewall's Point in Brookline (the present Kenmore Square), the other from Boston to South Boston. The resulting basins would be connected by raceways. At high tide, water would be allowed to flow into the Back Bay basin and through the connecting raceways into the South Boston basin, before emptying into Boston Harbor at low tide.

Not everyone in Boston supported Cotting's scheme for the industrialization of the Back Bay. The following letter, which appeared in the *Daily Advertiser* in early 1814, expressed concern about the impact the project would have on the appearance and health of the city:

> *Citizens of Boston! Have you ever visited the Mall* [a promenade at the western edge of the Common]*; have you ever inhaled the western breeze, fragrant with perfume, refreshing every sense and invigorating every nerve? What think you of converting the beautiful sheet of water which skirts the Common into an empty mud-basin, reeking with filth, abhorrent to the smell, and disgusting to the eye? By every god of sea, lake, or fountain, it is incredible.*

However, enthusiasm for industrial development was so prevalent in these years that proponents had little difficulty persuading the commonwealth to authorize the Mill Dam scheme. Thus on June 14, 1814, the Massachusetts legislature incorporated Uriah Cotting, Isaac P. Davis, William Brown and associates as the Boston & Roxbury Mill Dam Corporation to carry the Cotting plan to completion. The corporation was given license to "lease or

sell the right of using the water [thereby generated]…upon any terms, and [in] any manner they may think." They were also authorized to sell 3,500 shares to capitalize the venture. Since the conditions of the economy in the immediate postwar period were unfavorable to manufacturing ventures, however, the project was delayed for four years.

When Boston & Roxbury Mill Dam stock was finally offered for sale in 1818, investors snapped it up with great enthusiasm. Cotting, who drafted the twenty-four-page prospectus for the project, contended that Mill Dam had the potential to provide power for eighty-one mills, including six gristmills, six sawmills, sixteen cotton mills, eight woolen mills, twelve rolling and slitting mills and also facilities for the manufacture of cannons, anchors, scythes, grindstones, paint and other manufactured goods. While the Mill Dam would cost $250,000, a huge sum at that time, Cotting estimated that it had a potential to generate about $520,000 in income per year. Here, clearly, was an investment opportunity not to be missed! One determined investor is said to have crawled through Cotting's office window in his determination to procure Boston & Roxbury Mill Dam shares.

The plan as finally carried out eliminated the South Boston basin. The Mill Dam would be confined to the Back Bay.

First, a mile-and-a-half-long, fifty-foot-wide stone dam was built from the foot of Beacon Hill to Sewall's Point in Brookline, enclosing six hundred acres of the Back Bay. Then a cross dam was constructed from Gravelly Point in Roxbury, subdividing the impounded area into two basins, a westerly full basin of about one hundred acres, and an easterly receiving basin of some five hundred acres. At high tide, the waters of the Charles would enter the westerly basin and pass through sluices into the easterly basin, turning turbines to generate power, before emptying back into the Charles at low tide.

In the end, the Boston & Roxbury Mill Dam proved a dismal failure. Cotting's optimistic predictions were completely erroneous. The cost of building the Mill Dam, which he had estimated at $250,000, proved to be a whopping $700,000. The number of manufactories established on the margin of the Mill Dam never exceeded three—a far cry from the eighty-one Cotting had predicted. In 1834, the Mill Dam Corporation generated a mere $6,133 in gross annual receipts, far short of Cotting's $520,000 estimate.

It is perhaps fortunate that Cotting died in May of 1819, two years before the completion of the project, for his public reputation was greatly damaged by the project's colossal failure. He was, incidentally, only fifty-three years of age at the time of his death.

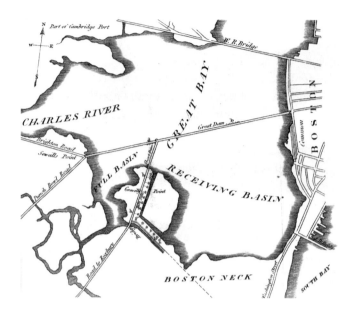

Hale's 1821 map showing the Boston & Roxbury Mill Dam Road extending across the Back Bay to Sewall's Point (present-day Kenmore Square) on the line of Beacon Street.

The failure of the Mill Dam project was in one respect most fortunate for the city. Had the Back Bay developed into an industrial zone, as Cotting hoped it would, the area would almost certainly not have become the handsome, elite, late-Victorian residential district of our day, one of the architectural and landscape design glories of Boston.

The Mill Dam, as already noted, benefitted the city by providing Boston with direct access to the towns on its western periphery. Prior to the construction of this roadway (present-day Beacon Street), persons traveling out to Brookline, Brighton, Watertown and other westerly towns were obliged to approach the area indirectly. Travelers could get there by way of the West Boston Bridge (a wooden toll bridge that linked the West End to Cambridgeport), or by way of the Boston Neck (the only overland route), across Roxbury to the Punch Bowl (now Brookline Village), a point of convergence of several westerly roads. The latter route involved making a great six-mile arc around the Back Bay.

On the other hand, it was some years before the Mill Dam Road carried much traffic, for it was a toll road. In addition, the ride across the Mill Dam to Brookline was neither particularly safe nor pleasant. William Lawrence, the future Episcopal bishop of Massachusetts, furnished a detailed description of the road's drawbacks in his memoirs: "It seemed a long drive…to our house in Longwood, for just beyond Charles Street the blocks of houses stopped. The Public Garden was then a dirty waste, and at Arlington Street was the city dump, where ashes and other refuse were thrown by tip-cars into the Back Bay."

This Winslow Homer engraving, showing a horse-drawn vehicle on the Mill Dam Road, appeared in *Ballou's Pictorial* on February 12, 1859.

Nor were the surroundings uninterruptedly rural. There were the perils of commercial traffic and (after 1834) railroad crossings to contend with:

> *Halfway across the Dam was the tollgate, where every team and carriage stopped to pay the toll: and just beyond, where at flood tide the Charles rushed in under a cut in the road to fill the Back Bay, and at ebb tide rushed out again, were the mill and the mill-wheel which ground corn hauled in from Brookline and Newton by farmers. At the fork "Brighton Road" ran out where Commonwealth Avenue now is, and the "Punch Bowl Road" to the left* [Brookline Avenue], *leading to the Punch Bowl Tavern in the Boston and Worcester—now the Albany—Railroad tracks. Over the road was a great sign, "Railroad Crossing: Look out for the Engine while the bell rings."*

Lafayette in Boston

In January 1824, U.S. Senator James Lloyd of Massachusetts observed that the visit to the United States of the Revolutionary War hero the Marquis de Lafayette, after more than forty years' absence, would likely touch off a national jubilee. Lloyd's prediction was fully borne out a few months later. Everywhere that General Lafayette went during his extended 1824–25 tour of the United States—whether to the north, south or west—he was received

with overwhelming respect and enthusiasm, and nowhere more so than right here in Boston.

Marie-Joseph Paul Yves Roch Gilbert du Motier, marquis de Lafayette, a nobleman of great wealth and high rank, threw in his lot with the American revolutionaries in 1777, doing so in violation of the orders of King Louis XVI to remain at home. Appointed a brigadier-general in the Continental army, the young French officer acquitted himself with distinction in several major battles of the Revolutionary War. It was Lafayette who commanded the French forces, some seven thousand strong, that stood alongside Americans troops at Yorktown in the final and decisive engagement of the Revolution. After his return to France in 1781, Lafayette played an important role in the early stages of the French Revolution as commander of the French National Guard, and again in the aftermath of the Napoleonic Wars as a member of the French parliament.

Lafayette's tour of the United States, when he was sixty-seven years of age, coincided with the fiftieth anniversary of the outbreak of the Revolution and served to reawaken America's veneration for its Revolutionary leaders, most of whom had by then passed on, as well as reaffirm a sense of common nationality, which had been badly damaged during the recent Missouri Crisis of 1819–20.

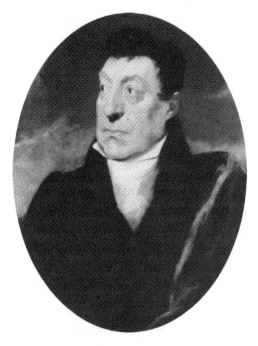

The Marquis de Lafayette, one of the heroes of the American Revolution, returned to the United States in 1824, after an absence of more than forty years.

Senator Lloyd's prediction of a national jubilee, the formal invitation that the City of Boston extended the French hero to include Boston on his itinerary, the marquis's own gracious acceptance (written in impeccable English in a small, neat hand) and the correspondence relating to the arrangements—some one hundred documents altogether—are to be found in the archives of the City of Boston. This writer had an opportunity to read through these documents recently, and gleaned some details about Lafayette's visit that no previously published accounts mention.

The competition for the Frenchman's time and attention during the few days he spent in Boston was intense. Senator Lloyd stole a march on his fellow citizens by writing the marquis directly from Washington in January 1824, some months before Boston sent its formal invitation urging him to include the city in his itinerary, offering the distinguished visitor the hospitality of the Lloyd Mansion on Beacon Hill's Somerset Street, adding that Mrs. Lloyd (a daughter of the prominent merchant Samuel Breck), "would delight to renew her acquaintance with one of the distinguished friends of her childhood."

The Lloyds were to be disappointed in their hopes of acting as the great man's Boston hosts. Instead a group of subscribers put the Amory Mansion (conveniently located at the corner of Park and Beacon Streets opposite the statehouse) at the disposal of the city for the entertainment of the marquis, thereby making the distinguished visitor "a guest of the public rather than of any individual."

The official invitation went out in early March, signed by Mayor Josiah Quincy Jr., the so-called Great Mayor (and the namesake of Boston's Quincy Market). It assured the general that nowhere in America would he meet with a more cordial welcome. Lafayette's gracious acceptance was written on May 26.

The Lafayette papers in the city archives contain several interesting letters from Harvard faculty member Edward Everett, who would later serve as Massachusetts governor and senator, as well as president of Harvard College. Then just thirty years of age, Everett asked Mayor Quincy to invite the marquis to attend Harvard's 1824 commencement, in which Everett was scheduled to deliver the Phi Beta Kappa address, an oration that made unforgettable impression, helping to raise him to the highest rank of American orators.

As one source notes of this famous speech, "Lafayette was present; and the closing words of the speech, directed to the aged hero, were delivered with such fervor that for some moments the audience sat spellbound, and then burst into a tumult of applause." Edward Everett, of course, was the same

A portion of this stately residence, at the corner of Beacon and Park Streets overlooking the common, built for merchant prince Thomas Amory in the 1790s, was rented by Boston Mayor Josiah Quincy for use by General Lafayette during his week-long visit to Boston in 1824.

orator whose lengthy oration at Gettysburg in 1864 was thrown into the shade by Abraham Lincoln's spare, poetic and powerful Gettysburg Address.

Everett fretted over the arrangements for Lafayette's Harvard visit. In another letter, written on the morning of the general's appearance, the nervous orator wrote Mayor Quincy, "I beseech you, not in my own name, but in that of the hundreds of feeble delicate ladies, fainting and pressed almost to death, who will be eight or nine hours, before you release them at best."

The timing of Lafayette's arrival was of such great concern that Boston sent a special agent, Benjamin Pollard, to New York City to report on his progress. On Friday, Pollard informed Mayor Quincy that the great Frenchman would be traveling to Boston by a coach and four via New Haven, Hartford and Providence. Lafayette breakfasted in Providence on Monday, August 23, and then traveled on to Roxbury, where he remained overnight. He entered the city on Tuesday morning, August 24.

A huge parade was organized to escort the general from the Roxbury boundary into Boston. There would be no scrimping on this occasion. By far the largest folder in the city archives collection of material relating

to this visit consists of the bills submitted to the city government for the elaborate parade and the many receptions that the municipality provided its celebrated guest.

Mayor Quincy, various city, state and federal officials, some twenty-three official marshals, a marching band, a corps of light dragoons, a battalion of light infantry and the members of the Society of Cincinnati (an organization of Revolutionary War veterans), as well as countless other invited guests, gathered at the city limits on the Roxbury Neck boundary at 9:00 a.m. on August 24 to receive the distinguished visitor. After a brief address of welcome by the mayor and a reply by the general, the various contingents lined up and the procession into Boston began with General Lafayette and Mayor Quincy at the center in an open barouche drawn by four white horses. As the parade moved across the Roxbury Neck and into the city, cannons atop Dorchester Heights, Fort Hill, Copp's Hill and other promontories fired a series of deafening salutes, church bells pealed a continuous welcome and the multitude lining the parade route cheered the general to an echo.

A three-mile-long route was followed, calculated to allow as many residents as possible to witness the grand spectacle. After moving up Washington Street, the procession turned onto Milk Street, then onto Broad, State and Court Streets (at the commercial heart of Boston) before reversing direction and passing down Tremont Street to Boylston Street, opposite the common.

As the marquis passed by Colonnade Row on Tremont Street (between present-day West and Avery Streets), it has been told, the general recognized an old acquaintance, the widow of Governor John Hancock, standing on the balcony of her residence. He immediately ordered his coach to stop so that he might salute this venerable lady with a deep bow, causing her to declare, "I have lived long enough!"

Whatever the truth of this story, the high regard the residents of Colonnade Row felt for Lafayette is evidenced by another document in the Boston archives collection—a petition bearing the names of all of the owners of the Bulfinch-designed Colonnade Row town houses (nineteen in all) asking the city to change the name of that fashionable complex to Fayette Place in honor of the marquis. The first signature on this interesting document was that of the great merchant and early industrialist Amos Lawrence.

When the parade reached its terminus on Boylston Street, the general and his party entered the common, where some 2,500 schoolchildren were lined up along the Tremont Mall with ribbons bearing portraits of Lafayette pinned to their jackets. One of these children, eleven-year-old Wendell Phillips, then a student at Boston Latin School, later described Lafayette's 1824 visit to Boston as a continuous "triumphal procession." A statehouse

reception, in which Governor William Eustis welcomed Lafayette on behalf of the commonwealth, followed.

Thus began the singular 1824 visit of the Marquis de Lafayette to Boston.

Abolition Scorned:
Boston's Response to Antislavery

Modern Bostonians take pride in the Hub's association with the antislavery crusade. It was here, we are fond of reminding outsiders, that the militantly antislavery newspaper the *Liberator* was founded in 1831 by radical abolitionist William Lloyd Garrison and that the most resolutely abolitionist organization in the United States, the New England Antislavery Society, was founded in 1833.

Yet in celebrating Boston's contributions to antislavery, we should not lose sight of less creditable facets of the Hub's relationship to the institution of slavery—a relationship going back to the earliest stages of the city's history. Boston-owned ships and Boston investment capital played a major role in the slave trade of the colonial era. And Faneuil Hall, the so-called "Cradle of Liberty," was built with money deriving, in part, from the Faneuil family's slave trade activities.

Most importantly, the economic well-being of nineteenth century Boston rested largely upon an industry—the manufacture of textiles—which depended upon the availability of cheap cotton from the slave South.

Thus it is hardly surprising that the abolitionist movement never enjoyed broad support here, either from the city's business elite or from its general population.

Only a handful of Bostonians, in fact, embraced the radical program that William Lloyd Garrison and his associates of the New England (later the Massachusetts) Antislavery Society espoused. The Garrisonian abolitionists called not only for the immediate abolition of slavery, but also—and far more disturbingly—the integration of blacks into American society as equal citizens.

Racial prejudice, endemic in American society in the early nineteenth century, was as firmly entrenched in early antebellum Boston as in other parts of the nation.

Nor was Garrison particularly well placed to make a case for abolitionism in socially rigid Boston. Garrison was from Newburyport, Massachusetts, where he had grown up in the direst poverty. His drunken father had

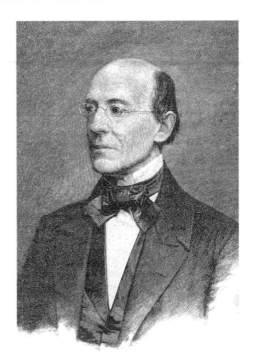

William Lloyd Garrison (1805–1879), editor of the *Liberator* and leader of Boston's radical abolitionists.

abandoned his wife and family when William Lloyd was three years old. As a boy, the future antislavery crusader had been forced to beg door to door for scraps of food to help keep his family from starvation.

Apprenticed to a printer, the largely self-educated Garrison soon demonstrated such talent as a writer and polemicist that he was given editorial responsibilities and began advocating a wide range of humanitarian reforms—temperance, pacifism and antislavery, in particular.

By 1829, Garrison rejected the widely held view that slavery should be phased out gradually (so-called gradualism) in favor of the far more disturbing doctrine of immediatism, which held that an immoral institution should cease everywhere at once, and that if one could justify the existence of slavery for a single moment, then it might be justified indefinitely.

Garrison's conversion to immediatism coincided with his only period of residency in the slave states. In August 1829, the young reformer had accepted the post of co-editor of the *Genius of Universal Emancipation*, a paper in Baltimore, Maryland, owned by the Quaker antislavery lecturer Benjamin Lundy. Preferring the lecture circuit to editing, Lundy left the management of the antislavery paper in Garrison's hands, with perhaps predictable results.

Having used the pages of the *Genius* to label ship owners who engaged in the domestic slave trade as "enemies of their own species—highway robbers

and murderers," Garrison soon found himself in serious trouble with the Baltimore authorities.

Sued for libel by ship owner Francis Todd, who like Garrison was a citizen of Newburyport, the editor was found guilty by a Baltimore jury and sentenced to a brief jail term. Upon his release from prison on June 5, 1830, after seven weeks incarceration, the militant abolitionist left Baltimore for good, moving to Boston, where he would reside for the balance of his life.

Garrison experienced great difficulty in procuring financial backing and subscriptions for an abolitionist paper in Boston. One or two well-connected men lent the venture enthusiastic support, notably Reverend Samuel J. May Jr. and lawyer Samuel Sewall Jr., who were both, interestingly, descendants of Samuel Sewall, the colonial-era judge who wrote the first abolitionist work published in America, *The Selling of Adam* (1700).

However, the vast majority of Bostonians, even such vaunted liberals as William Ellery Channing, were so put off by the extreme doctrines the militant young editor espoused that they declined to lend his venture their support and encouragement.

It was thus only with the greatest difficulty that the *Liberator* was finally launched on January 1, 1831. Its financial condition during the first several years of its existence was precarious in the extreme. It is significant that of the five hundred original subscribers, only 5 percent were from Boston, and most of these were residents of the city's small black community, situated on the northern slope of Beacon Hill. Free blacks comprised the bulk of *Liberator* subscribers in the years that followed.

Within eight months of the foundation of the *Liberator*, Nat Turner's slave rebellion broke out in Southampton County, Virginia, an uprising in which sixty white people were killed.

While there is no evidence that the rebels were aware of the existence of the *Liberator*—which, in any event, preached nonviolent resistance to slavery—Southerners were quick to blame the massacre on Garrison and his paper.

Bostonians were equally quick to offer reassurances to their Southern brethren that the *Liberator* did not speak for Boston. A letter from South Carolinian Benjamin F. Hunt asking for the suppression of the paper elicited a quick response from Boston Mayor Harrison Gray Otis, who pointed out that the *Liberator* and its editor enjoyed "insignificant countenance and support in Boston." And while contending that Bostonians hoped to see slavery eventually eliminated, "as did the best citizens of the South," Otis asserted that "there has been displayed among us, less disposition to interfere with the actual relations of master and slave in our sister states, than has been manifested in other places."

Garrison had complained in the very first issue of the *Liberator* that the antislavery crusade found "contempt more bitter, opposition more active, detraction more relentless, prejudice more stubborn, and apathy more frozen [in New England] than among the slaveholders themselves."

When Garrison and his followers moved to establish an abolitionist society in Boston a year and a half later, they again met opposition and contempt from the city's "gentlemen of property and standing."

Denied access to more ample meeting places, the organizers of the New England Antislavery Society were obliged to hold their very first public gathering not in Faneuil Hall, nor at the Old South Meetinghouse, nor at the Park Street Church, nor any of the well-known and accessible meeting halls of the city, but rather in the school room under the African Baptist Church (now the African Meetinghouse) on Smith Court in Boston's black neighborhood.

Nor did the apostolic dozen who participated in this January 6, 1833 gathering represent the first rank of Boston's leadership. The president, Arthur Buffum, was a Quaker manufacturer of hats who would a short time later be disowned by his fellow Quakers for supporting radical abolitionism. The group's first vice president, a man named Odiorne, is so obscure a figure that historians are unsure of his first name. The notorious Garrison assumed the post of corresponding secretary, thereby taking charge of the flow of information.

The spirit and determination that moved the organizers of this newly founded abolitionist society was expressed by Garrison as he stepped from the hall following the inaugural meeting, "We have met tonight in this obscure schoolhouse," he declared. "Our numbers are few and our influence limited; but, mark my prediction, Faneuil Hall shall ere long echo with the principles we have set forth."

One further example of the opposition Boston manifested toward abolitionism in its early years—in some respects the most dramatic—was the riot that occurred in Boston in response to a projected lecture by the British abolitionist George Thompson.

Garrison had made Thompson's acquaintance during an 1833 trip to England. So widespread was the opposition to the Thompson lecture that the owner of Boston's Julien Hall withdrew permission to use the facility, fearing that it would be attacked by an offended citizenry. An unfounded rumor then spread through Boston that Thompson would make an unscheduled appearance at a meeting of the Female Antislavery Society on October 21, 1835. A mob estimated at one thousand strong converged on this meeting place at 46 Washington Street, supposedly to prevent the lecture from

occurring (Thompson was not even in Boston at the time), at which point Mayor Theodore Lyman and the sheriff of Suffolk County intervened, asking the ladies to leave, which they did.

The mob, however, soon after apprehended Garrison, who had taken refuge in a nearby carpenter's shop. They tied a rope around his waist, intending to make an example of him. Fortunately, Mayor Lyman again intervened, placing the abolitionist leader under arrest "for his own safety," and booking him for "disturbing the peace." Garrison spent the night in jail, but the next morning had the last word on the issue of Boston's intolerance of abolitionism by inscribing on the jailhouse wall the following inscription: "William Lloyd Garrison was put into this jail on Wednesday afternoon, October 21, 1835, to save him from the violence of a 'respectable and influential mob,' who sought to destroy him for preaching the abominable and dangerous doctrine that 'all men are created equal' and that all oppression is odious in the sight of God."

Beacon Hill's David Sears:
The Squire of Longwood

Bostonians are well acquainted with the handsome bow-fronted, granite Sears Mansion at 42 Beacon Street, long an object of admiration for lovers of great architecture. The construction in 1819 of this Alexander Parris-designed structure, now the headquarters of the Somerset Club, heralded the introduction of the Greek Revival style into Boston.

Less well known, regrettably, are contributions the original owner of the mansion, David Sears Jr., made to Boston and neighboring Brookline as a philanthropist, public servant, businessman and landscape architect.

David Sears Jr. was born in 1787 with a proverbial silver spoon in his mouth. His father, David Sears Sr., a native of Chatham on Cape Cod, arrived in Boston in 1770, and "through unremitting application and judicious investment," chiefly in the China Trade, accumulated one of Boston's great fortunes. As the only child of this great merchant, young Sears stood to inherit immense wealth. He was extremely fortunate also in his social origins, for his mother (who died shortly after his birth) belonged to the prominent Winthrop family, descendants of Puritan Governor John Winthrop.

Educated by private tutors, David Jr. attended Boston Latin School and Harvard College, graduating from the latter institution in 1807. He then studied law in the offices of former Congressman Harrison Gray Otis, but

never followed the profession since his father needed his help in the family's various enterprises.

Handsome, wealthy and well connected, David Sears Jr. was understandably a favorite of Boston society in the early years of the nineteenth century. In 1809, he scored a great social triumph by securing the hand in marriage of the city's reigning belle, Miriam Mason, daughter of U.S. Senator Jonathan Mason, a woman "remarkable for her beauty, her vivacity, and her decision of character." That happy marriage, which produced ten children, lasted more than fifty years.

In 1811, the young couple traveled to Europe, the first of several lengthy sojourns on the continent. Residing in Paris during the final years of the First Empire, they came to know the former empress Josephine intimately. Years later David Sears Jr. would name his Brookline Estate Longwood, after Napoleon's final residence on the island of St. Helena.

Returning to Boston in 1814, Sears reentered the family business. Upon his father's sudden death in 1816, he came into the largest fortune that had ever descended to a young man in Boston—some $800,000, a huge sum in a day when a few thousand dollars rendered a man rich.

The granite, bow-fronted Alexander Parris–designed Sears Mansion at 42 Beacon Street.

Sears served in the Massachusetts legislature for many years as a member of both the House of Representatives and Senate, and was a leader, first of the Massachusetts Whig Party and later of the state's Republican Party. He was a political moderate and a strong supporter of President Lincoln.

Sears also made important contributions to public improvement over the years, contributions that included the establishment of the David Sears Charity for the city's poor (an agency that by 1880 held property worth $280,000) and generous financial support of the Massachusetts Humane Society, which he headed for a time.

His contributions to Boston's business life were equally impressive. Sears was a major investor in the early nineteenth century transformation of Boston's waterfront, most notably India Wharf, as well as efforts on behalf of the Boston & Roxbury Mill Dam Corporation, which sought to develop the Back Bay.

The Roxbury Mill Dam was the first major transportation project to significantly influence the development on the western edge of Boston. It involved the construction of a causeway as an extension of Beacon Street across the as yet unfilled Back Bay.

The principal promoter of the Mill Dam project, Uriah Cotting, saw two potential sources of profit stemming from this venture: utilization of the tidal power of the Charles River for manufacturing and the residential development in the northeast corner of the Brookline, adjacent to the western terminus of the projected roadway.

When Cotting died unexpectedly in 1819, three of his business associates—David Sears, Ebenezer Francis and Israel Thorndike—carried this grandiose Mill Dam scheme to completion. However, the venture proved much less profitable than its investors had expected.

Those who speculated in Brookline land were no more successful. Though the city's population was growing at a rapid rate (an incredible 42 percent in the 1820s), much buildable acreage was becoming available elsewhere in these years. Three major landfill projects were launched in the 1820s and 1830s—on Beacon Hill, in the West End (the Mill Pond area) and on the Roxbury Neck, all providing attractive and convenient sites for residential development closer at hand than Brookline.

Sears had personally purchased over two hundred acres of Brookline land for which there was now little demand. After several years of waiting, the hoped for demand still having failed to materialize, he decided to turn this Brookline acreage into a magnificent country estate called Longwood, which in time became the nucleus of one of the most exclusive Boston area suburbs.

Sears began by laying out broad streets across his property, which he named after persons, places or families with which he or his wife's kindred

had been associated. By the fall of 1849, he also planted some fourteen thousand trees on the property, including three hundred sycamores, three thousand English and Dutch elms, one thousand Norway maples and one thousand assorted oaks, all imported from England.

As Robert C. Winthrop noted of Sears's contribution to the area:

> *The principal portion of this attractive suburb was not merely laid out and improved, but largely built up, at Mr. Sears' expense; and his taste, liberality and foresight are alike evinced in the numerous villas and pleasure-grounds which lend to the vicinity an especial charm, as well as in the wise provisions which have thus far entirely protected them from unsightly and inconvenient neighbors.*

In 1855, *Ballou's Pictorial* described Longwood as "a beautiful tract. It is laid out on a liberal scale. Fine roads and carriageways intersect it in various directions. The noble woods are cleared of all underbrush, and there are many fine hedges, lawns and opening vistas, commanding beautiful views."

Sears was much more than a developer, however. He also sought to dominate the institutional life of the northeastern section of Brookline. He

David Sears, the Squire of Longwood, in an engraving dating from the 1860s.

made a gift of a schoolhouse to the neighborhood, and in 1860 built an imposing Norman-style church there, which he modeled after the one located in his ancestral village of Colchester, England. However, when he sought to impose a personal religious creed on this church, attendance dwindled.

Though Longwood had much in common with Alexander Jackson Davis's prototypical romantic suburb, Llewelyn Park, then being developed in New Jersey, there were some notable differences. While Longwood had beautiful vistas like Davis's suburb, Sears used a modified gridiron pattern in laying out his road system rather than the winding lanes Davis was making fashionable. Not only was the level topography at Longwood less suited to curvilinear roadways, but Sears drew many of his ideas from the French, who employed geometric regularity in landscaping, while Davis's landscaping model was the more wayward and inspirational English garden. In addition, while Llewelyn Park was created to accommodate an elite class in general, Longwood was created (at least in its initial stages) by an elite patriarch for his children and grandchildren.

David Sears Jr., the Squire of Longwood, died in his Beacon Street mansion in 1871, at the venerable age of eighty-three.

Horace Gray: Father of the Boston Public Garden

Horace Gray, the father of the Boston Public Garden, is a somewhat shadowy figure who deserves to be better known. A man of great vision and high public spirit, he was the prime mover and chief financial prop of the early effort to transform the swamplike western fringe of the Boston Common into the park that we today know as the Boston Public Garden.

Gray was very fortunate in the circumstances of his birth and upbringing. Born in 1800, he was the fifth son of William Gray, "Old Billy" Gray, the wealthiest man in New England (some said in the entire country), owner of a fleet of more than sixty square-rigged vessels.

The son of a Lynn master shoemaker, Horace's father made a fortune as a privateer during the Revolution. After the war, Billy Gray grew richer still trading with Russia and the East Indies. A man of unerring business judgment, he is said to have refused ever to be rushed. "I'll think on 't" was his favorite expression.

The senior Gray also pursued a highly successful political career, becoming one of the leaders of Massachusetts's Democratic Republican Party, the supporters of Thomas Jefferson, rising in the 1810 to 1812 period to the rank of lieutenant governor of Massachusetts.

In 1809, Old Billy moved his family from Salem to an imposing mansion at 57 Summer Street, corner of Kingston Street in downtown Boston. According to historian Samuel Adams Drake, Summer Street, now in the heart of the city's commercial district, was in the early nineteenth century "the most beautiful avenue in the city. Magnificent trees then skirted its entire length, overarching the driveway with interlacing branches, so that you walked or rode within a grove in a light softened by the leafy screen, and over the shadows of the big elms lying across the pavement."

Horace Gray received an excellent education under private tutors, earning an MA from Harvard in 1819. He then entered his father's mercantile house. Upon the elder Gray's death in 1825, Horace came into possession of the family's Summer Street mansion, which remained his home for the rest of his life.

In 1827, Horace married Harriet Upham of Brookfield, Massachusetts. Their eldest child, Horace Gray Jr. (1828–1902), was to become one of the nation's leading jurists, attaining the rank first of chief justice of the Massachusetts Supreme Judicial Court, and later associate justice of the United States Supreme Court. Another son (from a second marriage), John Chipman Gray (1839–1915), became a leading legal scholar and the longtime Story Professor of Law at Harvard.

Though Horace Gray's achievements may seem less important at first glance than the financial successes of his father or the professional successes of his sons, in laying the groundwork for the establishment of the Boston Public Garden, and sustaining that fledgling institution through the first decade of its existence, this worthy gentleman had a profound impact upon the quality of life in our city for which all of us should be thankful.

While active in business as a commission merchant (Horace Gray & Company with offices at 52 Broad Street), in bank and insurance company directorships and in the iron business, Gray's deepest interest always lay in horticulture and landscape design. Here we have an example of the shift of focus in many of Boston Brahmin families from a preoccupation with business and politics to increasing concern with educational, cultural and philanthropic ventures.

The year 1837 marked a major turning point in Horace's life. First came his second marriage (his first wife had been lost in a shipwreck in 1834) to Sarah Russell Gardner, daughter of the great merchant Samuel Pickering Gardner. Sarah's younger brother Jack would later marry Isabella Stewart of New York, the famous Mrs. Jack of Fenway Court. The Gardners, who also lived on Summer Street, maintained one of the finest gardens in Boston. But the garden behind Horace Gray's mansion, which extended back along

Horace Gray (1800–1873), the leading Boston-area horticulturalist who played a decisive role in the foundation of the Boston Public Garden.

Kingston Street, was even more celebrated, its outstanding feature being a conservatory in which Horace raised prize camellias and other exotic plants.

This year also marked the inception of the Boston Public Garden. On September 25, Horace Gray and several other avid horticulturalists petitioned the Boston City Council for permission to utilize the swampy twenty-four-acre site at the western edge of the Boston Common for the creation of a botanical garden. On November 6, they were given permission, with the condition that no buildings be erected on the land apart from a greenhouse and tool house.

Not until February 1, 1839, however, did Gray, George Darracott, Charles P. Curtis and other interested parties formally incorporate as the Proprietors of the Botanic Garden in Boston, with the right to hold and manage property worth up to $50,000, a substantial sum at that time.

The transformation of this acreage into a handsome public park was fraught with difficulty, for the site lay below street level and was subject to tidal flooding. First, a boardwalk was built from west to east from the Garden's entrance on Beacon Street, to be lined with ornamental plants and

trees. The proprietors hired an English gardener, John Cadness, to oversee these and other plantings.

In addition, a former circus building that stood near the corner of Beacon and Charles Streets was leased and converted into a conservatory for exotic plants and birds. Gray is credited with having imported the first tulips into this country in the late 1830s to embellish the grounds of the conservatory. This building contained four galleries, each devoted to a different variety of plant. The Boston Public Garden soon became a great place of attraction for the people of Boston.

Over the next nine years, the primary financial support for this singular public amenity came out of the deep pockets of Horace Gray.

Gray had in the meantime expanded his horticultural endeavors to the suburban town of Brighton, where he purchased a country estate of more than one hundred acres. Gray's Brighton horticultural venture was every bit as imaginative as his activities in the downtown. According to Wilder's *The Horticulture of Boston and Vicinity*, on Brighton's Nonantum Hill the wealthy Bostonian erected "the largest grape houses known in the United States, in which were extensively grown numerous varieties of foreign grapes. For the testing of these under glass in cold houses, Gray erected a large curvilinear-roofed house two hundred feet long by twenty-four feet wide. This was such a great success that he built two more of the same dimension."

Visible here are two mansions that stood on the grounds of Horace Gray's extensive Brighton estate on Nonantum Hill, where he erected the largest grape houses known in the United States.

Horace Gray's horticultural ventures, both at the Public Garden and in Brighton, ended abruptly between 1847 and 1848, when he lost the bulk of his fortune as a result of faulty investments. Compounding his problems was the destruction by fire a short time later of the Public Garden's beautiful conservatory.

Fortunately, Gray salvaged enough of his fortune to retain ownership of his Summer Street mansion with its splendid garden. Here the great horticulturalist lived out the last quarter century of his life in gentlemanly retirement.

At the time of Gray's death in 1873, scant note was taken of his passing in the city's press. His obituary in the *Boston Herald*, for example, identified him only as a former active merchant and the father of a state Supreme Court judge, with no mention of his singular contribution to the beautification of Boston as the founder of the Public Garden.

Nathaniel J. Bradlee: Master Builder of Boston

The Chestnut Hill Reservoir originally contained two basins—the existing one, which was named for the great Boston architect and engineer Nathaniel J. Bradlee, and a somewhat smaller body of water to the immediate west, named for leading industrialist Amos Lawrence. The latter body of water was turned over to Boston College about 1950, and has since been filled in. The university's lower campus and Alumni Stadium now occupy the site.

It is with the career of the namesake of the surviving basin—Nathaniel Jeremiah Bradlee—that this column is chiefly concerned. Though one of Boston's leading mid-nineteenth century men of affairs, the president of the Boston Water Board at the time of the construction of the Chestnut Hill facility and a prolific architect who designed more than five hundred Boston buildings, Bradlee's name is today largely forgotten.

Nathaniel J. Bradlee was born in Boston in 1829, the son of Samuel Bradlee, a well-to-do hardware merchant, and of Elizabeth Davis, member of another prominent Boston family. His maternal grandfather, Caleb Davis, a wealthy merchant and Revolution-era politician, served as the first Speaker of the Massachusetts House of Representatives under the Massachusetts Constitution of 1780.

Nathaniel Bradlee grew up on Avon Place (now Avon Street) in downtown Boston, a short street that runs from Washington Street, opposite Temple Place, to nearby Chauncy Street.

The Athens of America

In choosing civil engineering and architecture as a career, Bradlee was following in the footsteps of his paternal grandfather, another Nathaniel Bradlee, who had been a highly successful Boston builder.

Nathaniel received his education at the well-known Chauncy Hall School, located but a stone's throw from the family's residence on Avon Place.

This was all the formal education Bradlee ever received, but it must have been thoroughgoing, especially in mathematics and drawing, for when he graduated in 1846, the seventeen-year-old was immediately hired as a draftsman by one of Boston's leading architects, George Dexter, who was then at work with Edward Cabot on the landmark Boston Athenaeum building on Beacon Street.

Bradlee was quickly promoted to a full partnership, and when Dexter died in 1856, the then-twenty-seven-year-old Bradlee succeeded him as head of the firm.

Bradlee was both a prolific and highly versatile architect. In the 1850s, his first full decade of practice, he designed three new buildings for the Boston & Lowell Railroad; a mausoleum for the pioneer industrialist Francis Cabot Lowell; a gate at the Tremont Street entrance to the Boston Common; a new edifice for the First Church of Jamaica Plain; the Trinity Church Chapel on Summer Street; several Boston school buildings; the headquarters of the Provident Institution for Savings on Tremont Place; a riding academy at the

Prolific Boston architect and engineer Nathaniel J. Bradlee (1829–1888), who designed over five hundred Boston buildings.

foot of Beacon Hill's Chestnut Street; and several important commercial buildings, including the C.F. Hovey Department Store.

The most important early structure by Bradlee was Harvard College's handsome Gray's Hall, begun in 1858, the oldest of the three Victorian dormitories that still stand in the southern half of Harvard Yard.

In 1856, Bradlee married Julia R. Weld, daughter of a well-to-do Baltimore merchant. They had three daughters and resided in Roxbury.

Bradlee designed many South End structures, including several elegant blocks of townhouses. Other buildings by Bradlee in that section of town included two churches of note: the Springfield Street Church, dating from 1860, and a new building on Union Park Street for Reverend Edward Everett Hale's South Congregational Church, completed between 1872 and 1874. Bradlee also designed the landmark St. Cloud Hotel, situated at the corner of Union Park and Tremont Streets, a marble apartment building of the popular French flat variety.

Though Bradlee designed numerous Back Bay structures, including over twenty residences, and a new headquarters of the Second Church of Boston on Boylston Street, he left less of a mark on this new district than on the South End and the commercial area.

Bradlee also played an active part in public affairs, serving as an elected at-large member of the Boston Water Board from 1865 to 1871, the public agency that managed the city's water supply system.

During the last three years of his service there, Bradlee was the body's president. Under his leadership, some forty-eight miles of new pipes were laid out and water service was extended to thousands of new homeowners and businesses. In addition, the massive Chestnut Hill Reservoir was completed in 1870, his last full year at the helm of the board; the larger of the reservoir's basins was named in his honor.

Bradlee served the water board in other ways. In 1868, he authored the first published history of Boston's water supply system, a work entitled *A History of the Introduction of Pure Water into the City of Boston*. He also designed the handsome Cochituate Standpipe, which still stands on the site of a Revolutionary War fort in Roxbury's Highland Park.

Bradlee was noted both for his cordiality and absolute honesty. When he retired from the presidency of the water board in January 1871, its members praised the "able, impartial, and dignified manner" in which he had always conducted the body's meetings. His reputation for honesty was such that he was named as trustee for no less than fifty large Boston fortunes over the course of his career.

In 1869, Bradlee took up a particularly challenging civil engineering project by accepting a commission from the City of Boston to move the

seven-story Pelham Hotel, situated at the corner of Tremont and Boylston Streets (on the site of the Little Building) several feet back on its lot to allow for the widening of adjacent streets. This was no small undertaking. The massive structure covered 5,200 square feet and weighed an estimated ten thousand tons!

As the *Boston Globe* noted of this feat, "Such an undertaking was considered almost impossible...Larger buildings had been raised but none of equal size were ever removed." The Pelham Hotel was successfully moved under Bradlee's direction, an accomplishment that attracted much favorable comment, accounts of it appearing in publications not only in the United States but in Britain, France and Germany. Later the architect-engineer also moved the Boylston Market building.

In 1869, Bradlee succeeded in moving Boston's seven-story Pelham Hotel several feet back on its lot to allow for the widening of adjacent Tremont Street, a considerable engineering feat. The massive structure covered 5,200 square feet and weighed an estimated ten thousand tons.

The Boston Water Board was the only elective office Bradlee ever held, though he was a candidate for mayor in 1876, having received the Republican nomination for that office. In endorsing his candidacy, the *Boston Herald* noted that Bradlee was a "pure and upright man who though differing from the members of the [Republican nominating] convention on important questions of national politics, is no partisan and casts his vote as his conscience tells him." A Republican had been elected mayor of Boston the year before by a fairly comfortable margin and, given his excellent public reputation, under normal circumstances Bradlee's prospects would have been quite good.

Unfortunately, his nomination came at an inopportune moment for the Republican Party nationally—in the midst of the highly controversial 1876 presidential contest, a protracted contest that would end in the election of Republican Rutherford B. Hayes by the margin of a single electoral vote, notwithstanding a substantial popular vote victory for his Democratic opponent, Samuel J. Tilden.

The city's Democratic leadership attributed Bradlee's defeat by Democrat Frederick O. Prince to "the outrageous conduct of the Republican Party throughout the country," and as the "express[ion of] the sentiment of an outraged people." Under more favorable circumstances, Bradlee, who lost this election by a scant 2,300 votes, would have stood a much better chance. When again nominated for the office in 1887 by an independent Citizen's Ticket, Bradlee, who was in declining health, refused the nomination.

It was as an architect and engineer, however, that Nathaniel J. Bradlee made his mark on the history of Boston, continuing to design significant buildings into the 1880s. The most notable post-1870 Bradlee structures included the landmark New England Mutual Life Insurance Company building in Post Office Square (demolished in 1946), the Young Men's Christian Union building on Boylston Street, dating from 1875 (now an official City of Boston Landmark) and the Boston & Maine Railroad Depot in Haymarket Square. Bradley also designed hotels, department stores and commercial buildings in the last two decades of his career. One notable structure was Palladio Hall in Roxbury's Dudley Square, a property now on the National Register of Historic Places, which the architect built for himself (he was apparently considering relocating his architectural firm there, though he never did so).

Nathaniel J. Bradlee's life was cut short in December 1888 when he suffered a fatal stroke aboard a Boston & Fitchburg train while on a business trip to Keene, New Hampshire. He was fifty-nine years of age. With the death, as the *Globe* noted, Boston lost "one of [the] most successful men" of that era.

Part IV

West of Boston

This section of *Boston Miscellany* examines the impact Boston's growth had on its hinterland, especially areas lying west of the city.

The second major step in the filling of the Back Bay, following construction of the Mill Dam Road in 1821, was the building in the mid-1830s of the first western railroad, the Boston & Worcester, across that increasingly polluted and odiferous body of water. This was followed, beginning about 1860, by the systematic filling of the Back Bay, an operation that took some twenty-five years to complete. As the filling proceeded, many of Boston's major institutions began moving from the city's congested downtown to this new upscale neighborhood to the west.

The search for a pure and reliable water supply for Boston's mushrooming population also took a mostly westerly direction, proceeding in several giant steps over the course of nearly a century, first out to Lake Cochituate in Needham in 1848, then out to the Wachusett Reservoir and dam in Clinton at the turn of the twentieth century and finally to the massive Quabbin Reservoir in Central Massachusetts in the 1930s. The three columns that follow on that topic are designed to provide a short overall history of the water supply story. As a frequent lecturer on the topic, as well as the founding president of the Metropolitan Waterworks Museum, it is a subject that has long interested this writer.

The final three pieces deal with the equally fascinating history of the Charles River estuary, the portion of the river between Watertown Square and Boston Harbor. These columns likewise provide an overall history of the transforming changes that that section of the river experienced (from natural waterway, to commercial and industrial artery to the "People's River" of our day), a topic I dealt with more comprehensively in my 1998 book, *The Charles: A River Transformed.*

1835: The Year of the Railroads

An event of transforming importance to the future of Boston and New England occurred in 1835—the inauguration of the region's first steam-powered railroads, three of them in a single year, and all headquartered in Boston.

Each of these pioneer railroad lines ran from Boston to a major population center to the north, west or south: the Boston & Lowell stretched northward, to the regions key textile center; the Boston & Providence southwest to the principal port of neighboring Rhode Island; and the Boston & Worcester due west to Massachusetts largest interior city. With the opening of these lines in mid-1835, Boston became, temporarily at least, the railroading capital of the nation.

While these were not the first steam-powered railroads to be built in the United States (that distinction belongs to a South Carolina line), railroading in America was nonetheless a Boston idea. The pioneer railroad in the United States, the Granite Railway, a horse-drawn line established in 1826 to carry stone from the Quincy quarries to dockside on the Neponset River, was founded by Boston entrepreneurs.

Moreover, the city's financiers played a key role in the building and management of railroads all across the nation between 1830 and 1850.

Why were Bostonians so deeply interested in building and owning railroads?

As America spread westward in the early nineteenth century, Boston was finding it harder and harder to compete, lying as it did in the northeastern corner of the nation, a location ideal for engaging in oceangoing trade, but increasingly remote from the nation's interior markets and resources. While New York City (which by the 1830s was both the nation's largest city and most active port) was linked to the interior by a system of natural and manmade waterways—the Hudson River, the Erie Canal (completed in 1825) and the Great Lakes—Boston was separated from the nation's developing heartland not only by formidable distances, but also by the intervening barrier of the Berkshire Hills. Only by building railroads, especially a western line linking New England to the Hudson, could Boston remain reasonably competitive.

In addition, the New England region's own developing industrial economy required speedier modes of transportation than could be furnished by horse-drawn vehicles moving along interior roadways, or even canal boat plying manmade local waterways such as the Middlesex and Blackstone Canals.

The opening of the B&L, B&P and B&W lines in 1835 marked the first step in the creation of an elaborate network of tracks that by the 1850s

linked Boston to the nation's interior markets and resources. By mid-century, some three thousand miles of railroads would exist in New England alone.

It should be emphasized that many elements of the state's population were initially quite doubtful about railroads. In the 1830s, steam power was as yet a relatively new and uncertain technology. Early railroad proposals visualized freight and passengers being drawn by teams of horses, with all of the problems reliance upon animal power would entail. As late as 1828–29, a committee of the Massachusetts legislature recommended that the state deal with its transportation problem by constructing an elaborate system of canals, to be funded from the proceeds of a state lottery.

The Boston business community, however, was highly supportive of the railroad construction idea, the proposal for a western line (via Worcester) being especially popular. In 1829, pro-railroad Bostonians met in Faneuil Hall to urge that the city government itself undertake the construction of a western line, and that it appropriate a million dollars to that end.

Not only was there disagreement about whether a western railroad was feasible, but also over who should pay for its construction. In 1830, Massachusetts Governor Levi Lincoln proposed that the state build a line that

The Back Bay was a point of convergence of two of the three pioneer New England railroads. In this 1840 engraving, we see a Boston & Providence train heading into Boston, while in the background a Boston & Worcester train heads west toward its terminus in Worcester, forty miles away.

would pass through Worcester (his hometown), but this proposal was defeated by a powerful combination of those intent upon keeping taxes low, those with vested interests in existing transportation facilities (turnpikes and canals) and legislators from towns that the contemplated railroad would by-pass.

In the end, proponents of railroad building resorted to private financing through state-incorporated stock companies.

The first such corporation to be formed was Boston & Lowell, founded on June 5, 1830. The fast-growing industrial city of Lowell, founded in 1822, had need of a mode of transportation more reliable than the Middlesex Canal (built in 1803), which froze in the winter months. The prime movers in the establishment of the B&L Corporation were the Boston Associates, under dynamic entrepreneur Patrick Tracy Jackson, the group that had founded Lowell back in 1822.

Despite the B&L's earlier incorporation, however, it was the Boston & Worcester, chartered on July 23, 1831, that established the first regular service in Massachusetts.

Not all communities, it should be emphasized, wanted railroads built in their midst. Railroad technology was still quite primitive in the early 1830s. These steel behemoths were noisy, dangerous mechanisms. They belched huge quantities of smoke and cinders into the air (sometimes setting fire to surrounding property), and were susceptible to frequent explosions, derailments and collisions. Any community through which a railroad passed could expect to experience property damage and loss of life.

Originally slated to extend through Watertown and Waltham, the B&W ran into considerable resistance and had to be shifted southward through more rural Newton. Then because the town of Brighton objected to the route as altered, the route was shifted from the center of that town to the margin of the Charles River. In addition, when the owners of a local turnpike company objected to the probable impact the railroad would have on their business, the route through Framingham Center had to be moved southward.

Construction of the B&W began in August 1832, passing over the open water of Boston's Back Bay via a 170-foot-long trestle and embankment. By mid-April, the line was already running passenger trains from Boston to the Davis Tavern in West Newton. By July 1834, it had reached Wellesley Hills. It reached Westborough in November and opened for regular service all the way to Worcester on July 4, 1835.

Much of the credit for the rapid completion of the B&W Railroad must go to the line's visionary president, Nathan Hale, sometimes referred to as the "Father of the American Railroad." A prominent newspaper publisher,

Nathan Hale (1784–1863),
newspaper editor and founding
president of the Boston & Worcester
Railroad.

owner of the *Boston Daily Advertiser* (the first New England daily), Hale
repeatedly advocated the building of a western railroad in the pages of his
paper. He held the post of president of the B&W from 1831 until 1850.

Hale also played a key role in the creation of the Western Railroad, built
between Worcester and the New York boundary between 1836 and 1841,
which in combination with the B&W (the combined lines were afterwards
called the Boston & Albany) provided Boston and the whole New England
region with the lifeline to the west that was so important to its long-term
economic health.

Institutional Migration to the Back Bay

In the period 1857 to 1882, a major portion of the Charles River tidal estuary—
some six hundred acres of unattractive mudflats—were systematically filled
and improved to create the most elegant residential neighborhood in the city,
Boston's fashionable Back Bay. The new district was laid out by architect
Arthur Gilman, whose ambitious plan called for the creation of four east–
west avenues intersected by cross streets at intervals of 548 to 600 feet. At

the center of this grid would be Commonwealth Avenue, a 200-foot wide Parisian-style boulevard with a public park running between two roadways. The new district at the western edge of the downtown quickly emerged as the neighborhood of preference for the city's elite.

Another remarkable consequence of the creation of the Back Bay was the wholesale migration to the new district in the 1860 to 1910 period of Boston's great public institutions—its leading churches, schools, museums and libraries. The Back Bay's developers sought to encourage this removal by setting aside generous parcels of land for institutional use, reasoning that both the district's prestige and real estate values would thereby be enhanced. Their hopes were crowned with remarkable success.

Prior to the filling of the Back Bay, it should be noted, almost all of Boston's institutions had been located in the downtown. A combination of factors now served to push them out of the older section of town. For one thing, the value of downtown real estate was rising so rapidly that cash-poor institutions were encouraged to sell their cramped headquarters and use the proceeds to construct more ample facilities in the new district to the west. In addition, many of the patrons of these institutions were themselves now moving to the Back Bay. Still another incentive was provided by the Great Boston Fire of 1872, which leveled sixty acres at the heart of the city, thereby displacing some Boston institutions.

Churches were among the first to migrate. The earliest public building constructed in the new district was the handsome Unitarian Arlington Street Church, built between 1859 and 1861 at the corner of Arlington and Boylston Streets, opposite the Boston Public Garden. That congregation's previous home had been on Federal Street in the downtown.

Other churches that moved to the Back Bay in the 1860s included the Central Congregational Church, formerly on Winter Street, which took up residence in 1867 at the corner of Newbury and Berkeley Streets; also, the city's oldest religious society, the First Church of Boston, moved from Chauncy Place to a new building at Berkeley and Marlborough Streets in 1868.

This migration of churches intensified in the 1870s, when five more downtown congregations moved to the Back Bay. The 1870s was to witness the construction of the district's most important religious edifices. In 1871, Boston's historic Unitarian Brattle Square Church moved from the site of the present city hall to a new headquarters at the corner of Commonwealth Avenue and Clarendon Street, the building that now houses the First Baptist Church. This Henry Hobson Richardson–designed structure, notable for its distinctive frieze by F.A. Bartholdi, is one of the architectural treasures of Boston.

West of Boston

The Old South Meetinghouse, Boston's Third Church (Unitarian), was abandoned by its congregation in 1874, in favor of a magnificent North Italian Gothic–style building, the so-called New Old South Church, designed by Cummings & Sears, situated at the northwestern edge of Copley Square, another of the district's distinctive landmarks.

The most famous church in the Back Bay, H.H. Richardson's Romanesque Revival Trinity Episcopal Church, was built following the destruction of its original home on Church Green in the Great Boston Fire of 1872. The new building opened its doors in 1879.

Several of the city's key cultural organizations also relocated from the downtown to the Back Bay in these years. The Boston Society of Natural History (precursor to the Boston Museum of Science) moved from Mason Street to a handsome new edifice on Berkeley corner of Boylston Street in 1862.

Boston's Museum of Fine Arts, which had previously occupied the top story of the Boston Athenaeum at 10½ Beacon Street, moved in 1876 to an elaborate Ruskinian Gothic building on the south side of Copley Square, on the site now occupied by the Copley Plaza Hotel. Unfortunately, this unique edifice was taken down after the MFA's removal to the Fenway in 1909.

Then in 1900–1901, two of the city's great cultural institutions—the Boston Symphony Orchestra and the Massachusetts Horticultural Society—also moved from the downtown to the Back Bay, taking up positions in elaborate new buildings on opposite sides of Massachusetts Avenue.

Prior to its removal, the Boston Symphony, which dated from 1881, had performed at the music hall on Winter Street. Its Back Bay building, designed by the renowned McKim, Mead, and White architectural firm, opened in 1900.

In the following year, the Massachusetts Horticultural Society, founded in 1829, moved from Tremont Street, opposite the old Granary Burial Ground, to a new headquarters on Massachusetts Avenue, a handsome Classical Revival building designed by Wheelwright & Haven. So valuable had its downtown property become by the 1890s that the society was able to fully cover the cost of its much larger Back Bay building from the proceeds of the sale of the much smaller downtown structure.

Other cultural organizations quickly followed these pioneer institutions into the new district at the turn of the century, including the New England Conservatory of Music and the Boston Opera House, both situated on Huntington Avenue, a stone's throw from symphony hall.

Several institutions of higher learning also found their way into the Back Bay in the second half of the nineteenth century. In 1859, supporters of

Boston's Museum of Fine Arts, moved from the top story of the Boston Athenaeum at 10½ Beacon Street in 1876 to a Venetian Gothic–style building on the south side of Copley Square, on the present site of the Copley Plaza Hotel. This unique building was taken down following the MFA's removal to the Fenway in 1909.

the newly organized Massachusetts Institute of Technology petitioned the Massachusetts legislature to authorize the construction of a headquarters for the school in the Boston Public Garden. Fortunately, the legislature rejected that suggestion. Instead MIT's first building was constructed in 1865 at the corner of Boylston and Clarendon Streets, next to the Museum of Natural History. MIT moved to its present campus in Cambridge in 1916.

Other schools came to the Back Bay as well. The Harvard Medical School moved from its original home, adjacent to the Massachusetts General Hospital in the West End, to a new building at Boylston and Exeter Streets in the Back Bay in 1883.

Boston University, which began on Beacon Hill in 1869, expanded into the Back Bay by the late nineteenth century. Its College of Liberal Arts occupied the site on Boylston Street that now accommodates the Boston Public Library's annex. Not until the 1940s did BU begin developing its Charles River campus west of Kenmore Square.

A number of important libraries also moved to the Back Bay in the late nineteenth century. Foremost among them was the Boston Public Library's main facility, previously located on Boylston Street opposite the Boston Common. The new edifice, which opened in 1895, a Renaissance Revival

The Massachusetts Institute of Technology's first building was constructed in 1865 at the corner of Boylston and Clarendon Streets, next to the Museum of Natural History. A second adjacent structure was added to the Boylston Street campus in 1883, but the site offered little additional space for expansion. MIT moved to its present campus in Cambridge in 1916.

masterpiece by McKim, Mead, and White, defines the western edge of Copley Square, and has been described as a building that demonstrated that "in America, as in Europe, the city would be a work of art."

Other important libraries and archives came in its wake. The Massachusetts Historical Society, moved to a new building on Boylston Street, on the western fringe of the Back Bay in 1899, abandoning its downtown location at 30 Tremont Street.

Thus, by the early years of the twentieth century, Boston's Back Bay had become the home of a great concentration of public institutions, a distinction that this unique Boston neighborhood continues to enjoy to the present day.

Water for the City: Tapping Lake Cochituate

When Boston's earliest settlers established themselves on the Shawmut Peninsula in mid-1630, they were attracted to the location, in large part, because of its ample water supply.

Early accounts frequently refer to the "sweete and pleasant" springs on Shawmut. The names that the town government later gave to two of Boston's

oldest streets—Spring Lane and Water Street—attest to the existence of this all-important water supply.

However, as Boston's population grew over the years—from a mere one hundred in late 1630, to eleven thousand by 1720, to about sixteen thousand on the eve of the American Revolution—this surface water supply quickly proved inadequate and residents were obliged to dig wells and to collect rainwater in cisterns to meet their needs. In addition, the quality of the town's water deteriorated. By the middle of the eighteenth century, Boston's water had become hard, discolored and offensive to the taste.

The city's health and safety, of course, hinged on the availability of an ample supply of water. Water was needed to combat two hazards—fires and epidemic diseases. The still largely wooden and close-packed town was a veritable tinderbox. No fewer than fifteen major fires roared through Boston between 1702 and 1794.

A 1760 conflagration destroyed several hundred tenements, warehouses and wharves. Another major fire, in 1787, reduced to rubble more than one hundred buildings in the southern part of town.

Water was also required to keep Boston's streets clean and thereby reduce the chances of cholera, smallpox and yellow fever outbreaks in the port city.

The water shortage worsened markedly after 1785 as the city's population began rising dramatically. From 1785 to 1825 alone, Boston's population shot up from sixteen thousand to fifty-eight thousand residents. By the 1790s, it had become clear that outside sources of water would have to be tapped for Boston to continue to grow.

In 1796, the Aqueduct Corporation, a privately owned company chartered by the Massachusetts General Court, was established to purchase the water rights to Jamaica Pond in West Roxbury. Noted civil engineer Loammi Baldwin of Woburn installed a network of subterranean wooden pipes from Jamaica Pond to Boston through which water was conveyed by gravity to subscribers.

Unfortunately, this system was unable to supply the more elevated sections of Boston, where some of the most elaborate residences were being constructed. Also, the demand for water was growing at such a furious rate that it soon exceeded the capacity of the relatively small Jamaica Pond.

By 1825, there was a consensus in Boston that a new water supply system should be built, but serious disagreement as to the form it should take. Should the system be privately or publicly owned, and how much water should it provide? Also, what sources should be tapped?

These questions remained unanswered for two decades. Finally, in 1845, Boston turned for advice to John Jervis of New York, the nation's leading

The introduction of Cochituate water to Boston on October 25, 1848, was a signal event in the history of the developing metropolis, an event celebrated with much enthusiasm and fanfare. Here we see the eighty-foot column of water that rose above the Frog Pond on the Boston Common to signal the arrival of this new, ample and healthy water supply for the use of a burgeoning metropolis.

water supply engineer, hoping that his considerable prestige would serve to resolve the water supply debate. Jervis had served as chief engineer of the 363-mile-long Erie Canal, the most elaborate public works facility in the United States. He had also overseen the construction of New York City's Croton Waterworks System, which was completed in 1842.

Jervis recommended that Boston build an ambitious, publicly owned system that would meet its water needs until about 1870. He further recommended that the supply be taken from Long Pond in Natick (now Lake Cochituate), the same source Baldwin had favored, and that a sizeable holding reservoir be built just outside the metropolis.

In March 1846, the Massachusetts legislature approved Jervis's plan by enacting the Boston Waterworks Act, which established a three-member waterworks board and authorized Boston to borrow up to $3 million to carry the plan to completion. In April 1846, Boston's voters added their approval by an overwhelming vote of 4,637 to 348.

That May the Boston City Council named its first Boston Water Board, consisting of Nathan Hale, James Baldwin (younger brother of Loammi II) and Thomas B. Curtis. The position of president of the water board went

to Hale, head of the Boston & Worcester Railroad and owner and editor of the influential *Boston Daily Advertiser*.

Exercising vigorous leadership at every stage of the project was Boston Mayor Josiah Quincy Jr., son and namesake of the "Great Mayor" who had built the city's Faneuil Hall Marketplace in the 1820s. Quincy held office from December 1845 to January 1849, from just before the inception of the project until just after its completion. His financial acumen was especially important to the success of the project.

Ground was broken for the new waterworks at a lakeside ceremony in which the mayor, with the assistance of Josiah Quincy Sr. and former President John Quincy Adams, turned the first shovels of earth. At a reception held just after this ceremony, Mayor Quincy commented that the name Long Pond lacked distinctiveness, proposing that an Indian name, "Cochituate," be substituted, a suggestion that was immediately adopted.

Under Jervis's direction, an aqueduct capable of delivering eighteen million gallons of water a day was constructed between Lake Cochituate and a receiving reservoir in Brookline (the present Brookline Reservoir), from which pipelines were constructed to several smaller feeder reservoirs in Boston. The project took twenty-six months to complete and cost almost $4 million.

The introduction of Cochituate water to Boston on October 25, 1848, was a signal event in the history of the developing metropolis, an event celebrated with much enthusiasm and fanfare.

The festivities began at sunrise with a one-hundred-gun salute and the ringing of church bells all across the city. A huge parade then marched through the streets to the Boston Common, where an ode by James Russell Lowell was sung by schoolchildren, followed by speeches by Mayor Quincy and Water Board President Hale.

Upon completion of the addresses, the mayor inquired if the people of Boston were ready for the introduction of Cochituate water into the city. A tremendous affirmative roar from the assembled crowd of 100,000 spectators signaled their assent, whereupon Quincy ordered the gate opened, thereby releasing a column of water which shot up from the center of the Frog Pond to a height of eighty feet.

Water for the City: Chestnut Hill and Wachusett

The decade of the 1850s was a period of extremely rapid growth for Boston, which saw the city's population increase by over 30 percent. The water needs

of this mushrooming metropolis quickly outstripped the delivery capacity of the Cochituate system.

The inadequacies of the system became apparent as early as 1859, when a major break occurred in the Cochituate Aqueduct at the point where it passed across the Charles River on the westerly edge of Needham. Since the four storage reservoirs near Boston held, at most, a four-day water supply, it became necessary to shut off service for all but domestic uses. Had a major fire broken out in Boston at this point, the city might have found itself without water, with devastating public safety consequences. The 1859 emergency prompted the Cochituate Water Board to recommend the construction of a much larger storage facility on the edge of the city: the present Chestnut Hill Reservoir.

It was five years, however, before definite steps were taken to create this expanded storage facility, a delay the water board blamed on the poor economic climate of the Civil War period. In 1864, Boston's city engineer recommended a site in Chestnut Hill for the contemplated reservoir, on the boundary of Brighton and Newton, land owned largely by Amos Adams Lawrence of the famous textile manufacturing family.

Finally, in April 1865, Governor John Andrew signed a bill authorizing the Cochituate Water Works to "take and hold, by purchase or otherwise" up to two hundred acres of land bordered by South Street on the north (now Commonwealth Avenue), Beacon Street on the south, Chestnut Hill Avenue on the east and an unnamed street "leading from said South Street to said Beacon Street, on the west."

During 1865, this land was purchased, surveys were made and trees and brush were cleared away. Formal construction did not begin, however, until the spring of 1866.

The building of a formal driveway around the reservoir was proposed during the summer of 1866 and won wide public support. After considerable debate, the water board authorized the construction of an eighty-foot-wide roadway. Beginning at a great entrance arch, this handsome avenue extended around the northern side of the reservoir, where it joined Beacon Street.

At times the Chestnut Hill reservoir workforce—consisting mostly of Canadian maritime and Irish immigrant stonemasons, teamsters and laborers—approached a thousand men. So paltry were the wages paid these workers, however, that in March 1867 the entire force went out on strike. Intent on keeping costs to an absolute minimum, the Cochituate Water Board immediately fired and replaced the entire force. In this era of abundant labor, American workers had little bargaining power. As one historian has written, "His only freedom was to work at the lowest wage and under the worst conditions acceptable to his hungriest rival anywhere, or not

to work at all." The wage at the reservoir in 1867 was $1.50 a day and the average workday was twelve to fourteen hours long.

In 1868, work was concentrated as much as possible on the smaller Lawrence Basin. It was opened formally on October 26 by Water Board President Nathaniel J. Bradlee, a leading Boston architect, who stated that more than 240,000 cubic yards of material had been removed from the basin. The capacity of the Lawrence Basin was 180 million gallons. It covered 37.5 acres and had a circumference of 1.17 miles. This body of water was filled in the 1950s by Boston College. Alumni Stadium and student housing now occupy the site.

During 1870, the larger Bradlee Basin was constructed. This magnificent body of water (the existing reservoir), with a storage capacity of 550 million gallons, covers 87.5 acres and has a circumference of 1.56 miles.

On October 25, 1870, on the twenty-second anniversary of the opening of the Cochituate Water Works, a delegation consisting of President Bradlee, Boston Mayor Nathaniel Shurtleff and members of the water board and Boston Board of Alderman and Common Council dedicated the Chestnut Hill reservoir. In his remarks, Bradlee noted that the cost of the project, $2.4 million, had exceeded expectations, but that "its value is in the security it gives to the life and health of the inhabitants." The total holding capacity of the completed facility was 731 million gallons.

Between 1870 and 1900, Boston's population more than doubled, rising from 250,000 to 560,000 (some of the increase occasioned by the annexation of surrounding cities and towns). The city's water supply system thus required further expansion. A number of stopgap measures were resorted to in the 1870s to increase the supply, including the construction of six small reservoirs on the Sudbury River and its tributaries, which provided another thirteen million gallons for the city. In addition, with the annexation of the City of Charlestown in 1874, Boston acquired the water rights to Mystic Lake, which added seven million more gallons to its overall water supply.

By the early 1890s, another serious water supply crisis loomed. The Cochituate Water Board predicted that the city would face serious shortages by 1898 unless substantial new sources of water could be found. In 1893, the state legislature ordered the Massachusetts Board of Health to investigate the problem and make recommendations. The upshot was an 1895 report, prepared by Chief Engineer Frederick P. Stearns, which pointed out that Boston's consumption of water was approaching eighty million gallons a day, while the capacity of the Cochituate system stood at a mere eighty-three million gallons. The margin between supply and demand was thus growing dangerously narrow.

Stearns advocated a comprehensive approach to the problem that would serve to meet the needs of Boston and surrounding municipalities for the next quarter of a century. After examining a number of water supply options, he settled upon the Nashua River as the most suitable source. The choice of the Nashua River reflected a reluctance on the part of Massachusetts water engineers to resort to filtrated water. Since the Nashua River Valley was sparsely populated, its water supply would require no filtration.

The Stearns Plan called for the building of a giant dam on the Nashua River at Clinton, Massachusetts, and the creation above the dam of a seven-square-mile reservoir with a storage capacity of sixty-three billion gallons, enough water to double Greater Boston's supply.

The Massachusetts legislature adopted the Stearns Plan on June 5, 1895, and created a Metropolitan Water District and Metropolitan Water Board to administer the new system. Stearns was subsequently hired as chief engineer.

The Wachusett Dam and Reservoir (as the Clinton facility was called) took several years to complete. When it was dedicated in 1906, it was the largest reservoir in the world, and had cost some $21.6 million to construct. It also

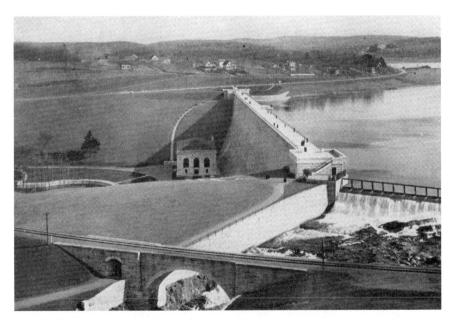

The Wachusett Dam and Reservoir was dedicated in 1906. It was the largest reservoir in the world, and had cost some $21.6 million. It also provided employment opportunities for tens of thousands of workers and acted as a magnet for skilled immigrant labor in a period when immigration into the United States was at an all-time high.

provided employment opportunities for tens of thousands of workers and acted as a magnet for skilled immigrant labor in a period when immigration into the United States was at an all-time high.

The Wachusett project greatly enhanced the reputation of its chief engineer, Frederick Pike Stearns, raising him to the leadership of the engineering profession. In 1905, he was elected president of the American Society of Civil Engineers. Subsequently Stearns planned the 1906–10 improvement of the Charles River Basin and also served as a member of the Board of Consulting Engineers of the Panama Canal.

Two facets of the development of Boston's water supply system should be emphasized at this point: one, the sources that the city tapped after 1895 moved progressively farther and farther west (from densely populated to sparsely populated precincts of Massachusetts, where the water was as yet untainted); and two, twentieth-century water supply projects, in contrast to those of earlier periods, involved the creation of massive storage reservoirs, which necessitated the inundation of whole communities. In the case of the Wachusett Reservoir, most of the town of West Boyston had to be flooded. The destruction of rural communities for the benefit of urban populations naturally generated a high degree of outrage among residents of the towns thus obliterated.

Water for the City:
Creating the Great Quabbin Reservoir

With the completion of the Wachusett Dam and Reservoir in 1908, Boston and the other eighteen cities and towns that comprised the Metropolitan Water District were furnished with a greatly expanded supply capacity, amounting to some 155 million gallons a day. The projectors of the Wachusett Reservoir had estimated that it would satisfy the metropolitan area's water needs for thirty years. Their estimate fell far short of the mark, however. By 1919, a combination of steadily increasing water consumption and the expansion of the district's boundaries through the addition of new cities and towns had raised the use level in the district to 130 million gallons, giving rise to renewed concern about eventual shortages.

Two significant steps were taken in 1919 to obviate the danger. First, a new public agency, the Metropolitan District Commission (MDC), was created to coordinate water, sewer and parkland administration in metropolitan Boston. In addition, the Massachusetts legislature ordered the preparation

of still another comprehensive study of the district's future water supply needs. The task of preparing this report would be a joint responsibility of the MDC and the Massachusetts Board of Health.

Boston's water supply planners had long since rejected the idea of using filtrated water. The search for water was thus pushed increasingly westward in a search for new sources of pure water.

The most promising new pure water source lay some fifty to sixty-five miles west of the city in the Ware and Swift River Valleys of central Massachusetts. As early as 1895, Frederick P. Stearns, the brilliant chief engineer of the Wachusett Reservoir, had identified the Swift River Valley (site of the present-day Quabbin Reservoir) as having a tremendous water supply potential.

The Swift River Valley had much to recommend it to water supply planners. Especially important was the sheer volume of pure water available there and also the basin-like topography of the valley. Moreover, there were no major industries on the banks of the Swift River. The valley's economy had been in the doldrums for years. Apart from some farms and orchards, a handful of small mills and a seasonal tourist industry, catering to mostly New York hunters and fishermen, the area was economically undeveloped.

Another great advantage of the Swift River Valley lay in its low population—just thirty people per square mile. Low population density and the lack of industry would, of course, simplify the process of appropriating the land. Property values were low to begin with, and once rumors began circulating of eventual government land-takings, they fell even more. As Thomas Conuel wrote in his book *Quabbin: The Accidental Wilderness*:

> *It is easy to see why the Swift River Valley was considered expendable by state water planners. No major businesses would be ruined, no major highways disrupted, no prominent landmarks buried by the waters of Quabbin. The Swift River Valley was a small, out-of-the-way place, totally lacking the political and financial power that could have saved it.*

While the MDC–State Board of Health Report, which appeared in 1922, recommended that the waters of the Ware and Swift River Valleys be tapped by the Metropolitan Water District, the more pressing needs of the city of Worcester and communities in Berkshire, Franklin and Hampshire Counties and the Merrimack River Valley needed to be addressed first.

Not until 1928 was the first tangible step taken to exploit the Ware and Swift River supplies. This involved the building of a 12.5-mile-long aqueduct connecting the Wachusett Reservoir to the Ware River, a major public works

undertaking. The twelve-foot-wide, massive, horseshoe-shaped conduit, known as the Wachusett-Colebrook Tunnel, had to be blasted through solid rock at a depth of two hundred feet. The arrival in 1931 of the first water from the Ware River by way of this tunnel probably saved the Wachusett Reservoir from drying up, for a prolonged drought had reduced Wachusett's supply to less than 20 percent of capacity.

During the early 1930s, the Wachusett-Colebrook Tunnel was extended ten miles farther west to link with the Swift River. This section of the aqueduct, in contrast to the easterly portion, lay entirely above ground, some thirteen feet high and eleven feet wide.

In the meantime, preparations were being made for the removal of the residents of the Swift River Valley. In creating Quabbin Reservoir, four towns (Greenwich, Enfield, Dana and Prescott) were inundated by the waters of the Swift River and its tributaries. These towns were extensively photographed by the MDC, which also organized the removal of their cemeteries and the purchase of the property. The resentment the destruction of these towns generated is still palpable in central Massachusetts today.

In early 1938, the last residents of the four communities bid an emotional farewell to their homes and the associations of a lifetime. The following account, which appeared in the *Springfield Morning Union*, describes the scene in one of the communities, Enfield, as it passed into history on April 28, 1938:

> *Under circumstances as dramatic as any in fiction or in a movie epic, the Town of Enfield passed out of existence at the final stroke of the midnight hour.*
>
> *A hush fell over Town Hall, jammed far beyond its ordinary capacity, as the first note of the clock sounded; a nervous tension growing throughout the evening had been felt by both present and former residents and casual onlookers.*
>
> *The orchestra, which had been playing for the firemen's ball throughout the evening, faintly sounded the strain of Auld Lang Syne…muffled sounds of sobbing were heard, hardened men were not ashamed to take out their handkerchiefs.*

The building of Quabbin itself had begun two years earlier in 1936. The chief engineer of the project was Frank Winsor. First, the waters of the Swift River were impounded through the construction of two huge dams at the southern end of the valley. The larger of the two, Winsor Dam, is some 2,640 feet long and 295 feet high. Goodenough Dike is 2,140 feet long and 264 feet high.

The larger of the two giant dams at Quabbin, the Winsor Dam, is some 2,640 feet long and 295 feet high. It was named for Frank Winsor, the chief engineer of the Quabbin project.

With the completion of the two dams in 1939, the filling process began, with the shape of the reservoir being determined by the basin-like topography of the valley.

The vast Quabbin Reservoir that slowly rose behind Winsor Dam and Goodenough Dike was 18 miles long and covered an area of 38.6 square miles. The giant reservoir's shoreline is an incredible 118 miles long. At its maximum depth, in front of Winsor Dam, the great reservoir is 150 feet deep, with an average depth of 90 feet at its center.

Not until 1946, seven years after the filling process began, did Quabbin reach its capacity, some 412 billion gallons of water. At that point, Quabbin enjoyed the distinction of being the largest reservoir in the world devoted exclusively to water supply uses.

Today the Metropolitan Water Resources Authority (MWRA), which took over the metropolitan area's water supply system in 1984, services some 2.5 million users in forty-six cities and towns. Construction of the Quabbin Reservoir provided the metropolitan district with a vast supply of high quality water, one of the finest metropolitan water supply systems in the nation, which it is estimated will satisfy the needs of the metropolitan area for many decades to come.

Bridging the Charles

Prior to 1908, when the construction of a dam at its mouth permanently excluding the tides, the Charles River Basin had an altogether different appearance from that of our day. In its natural state, it had been a tidal estuary, an arm of the sea garlanded by hundreds of acres of salt marshes and mudflats into which the onrushing and receding tides filled and emptied twice in every twenty-four-hour period.

This nine-mile-long body of water, extending from the harbor to a point just below Watertown Square, presented travelers with a formidable barrier, for the expanding and contracting basin could be crossed reliably only at a few specific locations.

Ferries were the earliest mode of cross-river public transport, operated by neighboring farmers who were licensed to transport passengers and goods for a modest fee. The first ferry, dating from 1631, operated between the foot of Copp's Hill in Boston's North End and Charlestown on the opposite shore. A second ferry, established in 1633, ran between Gerry's Landing (then the site of Watertown Village) and a hillside a mile or so up river in North Brighton, known as "the Pines." The third ferry, dating from 1635, linked the village of Cambridge (at present-day Harvard Square) with the so-called Roxbury Highway on the south side of the river, the main road between Cambridge and Boston, which skirted the as-yet-unfilled Back Bay, entering the city by way of the Roxbury Neck.

By 1662, traffic on the Roxbury Highway had grown to such an extent that a bridge was needed—to be known as the Great Bridge, the largest public works project yet undertaken in the Massachusetts Bay Colony.

The Great Bridge proved difficult to build and even more difficult to maintain. The original span, supported by hollow logs filled with stones, was swept away by a flood in 1685. In 1690, it was rebuilt on piles, a difficult technique since only hand power was available to raise the weight of the driver. Tradition tells us that as many as five thousand blows were required to propel some of the piles to a firm bearing. Because of the heavy costs associated with building and maintaining the Great Bridge, all of the surrounding towns were required to contribute to its support.

The Great Bridge was the only bridge across the Charles River Basin before 1786, with the exception of a narrow cart bridge at the basin's westernmost extremity in Watertown Square.

The transportation needs of Boston and its developing hinterland prompted the construction between 1786 and 1809 of three more bridges at the eastern end of the basin. Investors in these bridge-building

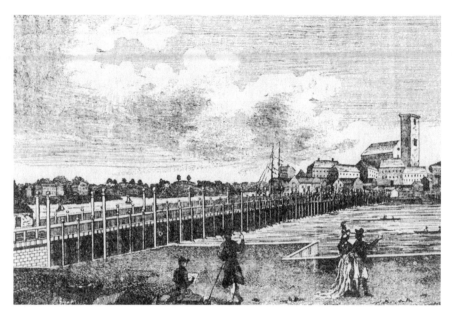

The elegant 1,503-foot-long Charles River Bridge, the first to be built out of Boston, opened on June 17, 1786, the eleventh anniversary of the Battle of Bunker Hill.

ventures not only stood to profit from the collection of tolls, but also from the development of the land they owned in adjacent districts. Since the cooperation of state and local governments was critical to the success of such enterprises, bridge-building companies engaged in a fierce competition for state and local support. So vigorous was this struggle that Cambridge historian Lucius Paige dubbed it, "the Battle of the Bridges."

First came the Charles River Bridge in 1786, which replaced the Charlestown ferry. A company consisting of John Hancock, Thomas Russell and eighty-two other investors was incorporated by the Massachusetts legislature to build this impressive structure, the largest yet constructed in the United States, with the right to collect tolls from passengers for a period of years to recoup their investment. The 1,503-foot-long span, supported by seventy-five piers of oak timber, was 42 feet wide. Other features included forty lamps for nighttime illumination and a 6-foot-wide walkway on each side for pedestrian traffic. On June 17, 1786, the eleventh anniversary of the Battle of Bunker Hill, a vast crowd gathered for the dedication of this elegant new edifice, which was opened amidst the pealing of church bells and the firing of cannons.

In 1793, the much-longer West Boston Bridge was built on the line of the present Longfellow Bridge. The longest of the river's bridges, this

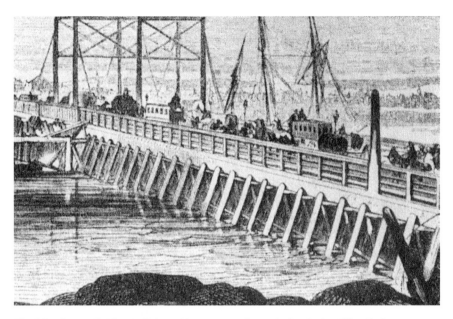

The West Boston Bridge, built in 1793 to connect Boston's developing West End to Cambridgeport. In announcing its completion, the *Columbian Centinel* proclaimed, "The elegance of its workmanship and the magnitude of the undertaking are perhaps unequalled in the history of enterprises."

span linked Boston's West End to Cambridgeport. It was built by the Cambridgeport Proprietors, a group headed by former Congressman Francis Dana of Cambridge, which owned extensive acreage in the eastern part of Cambridge. The West Boston Bridge was 3,483 feet long, more than double the length of the Charles River Bridge.

The third bridge built out of Boston, Craigie's Bridge, was dedicated in August 1809. It connected Barton's Point in the West End to Lechmere Point in East Cambridge. The prime mover in this venture was Andrew Craigie, former commissary general of the Continental army, who resided on Cambridge's Brattle Street, in the house that had earlier served as Washington's headquarters and would later be the residence of Henry Wadsworth Longfellow. Craigie and his business associates owned considerable property in East Cambridge.

As the road system west of Boston expanded in the early nineteenth century, other bridges were built. The River Street Bridge was constructed in 1810 to link Cambridge Street in Brighton with River Street in Cambridge, thereby providing a shorter route between the Brighton Cattle Market and the Faneuil Market in Boston via Cambridgeport and the West Boston Bridge. The Mill Dam Road (present-day Beacon Street) had been built across the

Back Bay in 1821. With its extension through Brighton in 1824, the North Beacon Street Bridge was built to carry the roadway across the Charles River into Watertown. The construction, in the same year, of Western Avenue in the northern part of Brighton required the building of two more bridges, the Western Avenue Bridge at the eastern end and the Arsenal Street Bridge at the western end of that thoroughfare. All of the bridges built between 1786 and 1824 were wooden toll bridges equipped with draws to allow for the passage of the wind-propelled vessels that then plied the Charles.

The building of the toll-free Warren Bridge in 1828 just to the west of the Charles River Bridge brought on a fierce legal dispute—the Charles River Bridge stockholders claimed that the new span violated the terms of their act of incorporation. After much litigation, the case was settled by the landmark 1837 U.S. Supreme Court Charles River Bridges decision that found in favor of the Warren Bridge.

In 1850, the last of the river's wooden structures, the Brookline Bridge, was built to link Brookline and Cambridge. Today the Boston University Bridge (formerly known as the Cottage Farm Bridge) occupies the site.

The Harvard Bridge, dating from 1891, a 2,165-foot-long and 70-foot-wide edifice, served to join Boston's Back Bay to the Cambridge flats, where the Massachusetts Institute of Technology would later be constructed. As one source noted of the Harvard Bridge, "Without it the location of the new Institute of Technology would have been unthought of."

With the damming of the river in 1908, the old wooden drawbridges were replaced by iron, concrete and brick structures of a more elegant and permanent design. Drawbridges were no longer needed since the river had ceased to be a commercial artery. The most notable of these twentieth-century structures was a handsome stone edifice, built between 1900 and 1906 as a replacement for the old West Boston Bridge. Called at first the Cambridge Bridge, it was renamed in honor of the poet Henry Wadsworth Longfellow in 1927. Designed by the renowned municipal architect Edmund March Wheelwright, this bridge is the most elaborate and handsome on the Charles River Basin. Its four distinctive turrets were said to have been inspired by a bridge in Prague.

Two additional spans were constructed in the twentieth century: the Weeks Footbridge (1927), which links Harvard University's Cambridge and Allston campuses, and the Eliot Memorial Bridge (1951) at Gerry's Landing, named for Charles Eliot, the great landscape architect who did so much to shape the character of the river of our day. Both are handsome neoclassical structures that blend readily with adjacent Harvard University riverfront buildings.

In all, fifteen bridges have been built across the Charles River Basin over the years, of which thirteen survive.

The Charles:
A Nineteenth-Century Commercial Artery

The Charles River Basin had a very different appearance and function in the nineteenth century from that of our day. Unsuited for residential development because of its tidal character, the basin developed instead into a commercial artery lined with numerous industrial and commercial facilities. As late as the 1890s, some two thousand masted vessels a year plied this important commercial waterway, servicing its many wharves.

Among the earliest manufactories to arise on the shore of the basin was the Watertown Arsenal, founded in 1816 by the U.S. Army. One of the federal government's chief concerns in selecting the Watertown site for this important facility was its accessibility by schooner to the various U.S. military installations in and around Boston harbor. Uncle Sam invested heavily in the arsenal complex, hiring prominent Boston architect Alexander Parris (the man who later designed the Quincy Market) to execute the design.

By 1820, the Watertown complex included a quadrangle of two-and-a-half-story buildings, storehouses, powder magazines, officer's housing and barracks for enlisted men, in addition to various shops for the use of the arsenal's smiths, carpenters and other workers. Prior to 1860, the facility was used chiefly for the storage and the manufacture of cartridges and wooden gun mounts. During the Civil War, however, a foundry and a laboratory were added for testing the strength of various materials, especially steel, which had come to replace wood and iron in the construction of gun carriages and other equipment. Through a succession of conflicts, this important federal facility has been at the cutting edge of military technology.

Though never assuming the magnitude that some developers envisioned, industrialization came early to the basin. In two major instances, entrepreneurs projected ambitious projects that either failed to materialize or were only partially fulfilled.

The founders of Cambridgeport visualized the creation of port facilities rivaling Boston's on the river's northern shoreline, in the vicinity of present-day Kendall Square. In 1805, they persuaded Congress to make Cambridgeport an official United States port of entry. While some progress was made toward this goal in the first few years, including the construction of canals, wharves and row houses near the Cambridge end of the West Boston Bridge, Jefferson's trade embargo of 1807 effectively killed the project.

Another failed industrial initiative was the Boston & Roxbury Mill Dam project, described in detail above.

West of Boston

This 1873 engraving of the Charles River's Brighton shore looking across the river toward Harvard Square shows a relatively undeveloped section of the shoreline, where Harvard University's Soldiers Field would eventually be laid out.

Greater success awaited the developers of the Lechmere section of East Cambridge. Preeminent among them was Cambridge landowner and speculator Andrew Craigie, who in 1809 built Craigie's Bridge connecting Lechmere Point to Boston's West End. By the 1850s, East Cambridge contained by far the heaviest concentration of commercial and industrial establishments in the basin area. Two canals, the Broad and the Lechmere, were eventually constructed to facilitate water transport in this developing industrial zone.

The most important early industry to locate in East Cambridge were several glassmaking establishments, which by mid-century had become the largest employers in Cambridge. Other important East Cambridge manufactories produced furniture, wooden products, sugar and brushes. Especially important in the second half of the nineteenth century was the meatpacking industry. By the 1870s, there were no less than nine packinghouses in East Cambridge, the largest being John P. Squire & Company, which occupied a twenty-two-acre site on Gore Street and employed some thousand workers.

The construction of railroads on both sides of the basin helped spur shoreline commercial and industrial development. Between 1834 and 1835, the Boston & Worcester Railroad was built on the southern side of the river, passing across the Back Bay on a 170-foot-long trestle known as the "dizzy bridge" and then skirting the Charles River through Brighton and Newton. The Fitchburg Railroad was completed in 1841 on the northern side of the river, and the connecting Grand Junction Freight Railroad in 1851. The

ready access to rail transportation these lines provided fostered large-scale industrial development along the river.

The Charles shoreline also became a center of the publishing trade. A complex of buildings lying between Western Avenue and River Street in Cambridgeport housed the Riverside Press. This company's history began in 1851, when Little Brown bought the old Cambridge almshouse and converted it into a book manufactory. The property was later acquired by H.O. Houghton & Company and expanded. In 1895, the Athenaeum Press, a division of Ginn & Company, was located on the river's edge in East Cambridge in a neoclassical brick and brownstone structure distinctively surmounted by a statue of Athena, Greek goddess of wisdom.

The systematic filling of the Back Bay, which was carried out in stages between 1857 and 1882 and added some six hundred acres to Boston's downtown, reoriented most of Boston's shoreline toward high quality residential development. Yet some industrial establishments continued to exist even in Boston until a fairly late date. A cluster of factories stood just west of Cambridge Street until the late nineteenth century. They included the headquarters of the Boston Gas Light Company, an organ factory, a coal and wood yard and a carriage factory at the foot of fashionable Chestnut

This photograph, dating from 1894, shows the indiscriminate mix of industrial and residential buildings to be found on the banks of the Charles River in the late nineteenth century. Here we have a view of the Cambridge shoreline just west of the North Harvard Street Bridge.

Street. Still another carriage-making establishment stood opposite Hereford Street in the Back Bay as late as 1876.

There was much industry in the upper basin as well. Industrial establishments here tended to cluster around the various river crossings. They hugged the southern shore of the river just outside of Watertown Square, the most notable establishment here being the Stanley Steamer factory.

In 1872, the massive Brighton Abattoir was built on the banks of the Charles in North Brighton. The sixty-acre complex boasted one thousand feet of river frontage, allowing schooners and sloops to tie up at its wharves, and included a large rendering house and fourteen slaughterhouses, ten of which were arranged under one continuous roof. In 1881, the Brighton Stockyards moved from Brighton Center to a parcel of land on lower Market Street adjacent to the abattoir. The laying out of the Boston & Albany Railroad's huge Beacon Park Freight Yard in Allston in the 1890s reinforced the area's industrial character.

With the damming of the mouth of the river in 1908, a fundamental transformation in the character of the Charles River Basin became possible—a change from a commercial artery to the "People's River"—making the Charles River Basin Greater Boston's most important recreational and visual amenity.

The Charles: A River Transformed

In two previous columns on the history of the Charles River Basin, I described the many bridges that were built across that waterway over the years (some fifteen in all) and how, in the course of the nineteenth century, the basin became a bustling commercial and industrial artery lined with countless manufactories and wharves. This column will describe the basin's transformation in the twentieth century into the leading recreational resource in the Boston area.

The Charles River Basin had once been both pristine and salutary. For thousands of years, native bands had availed themselves of its bountiful ecosystem, its abundant fish and game, to sustain and enrich a flourishing native culture. Even in the early nineteenth century, long after towns had arisen on the banks of the river but before the imprint of industrialization was deeply etched, the basin was still home to a wide variety of plants and animals.

The great painter Washington Allston, while a student at Harvard in the late 1790s, loved nothing so much as to wander along the banks of the tidal

Charles, drawing inspiration from the natural landscape. Pedestrians passing over the West Boston Bridge in the early nineteenth century reported seeing seals cavorting in the river. As late as the 1840s, fishing and duck hunting were popular pastimes all along its banks. And at mid-century, Henry Wadsworth Longfellow, who enjoyed a clear view of the Allston meadows from his home on Cambridge's Brattle Street, wrote a number of verses celebrating the river's beauty.

By the end of the nineteenth century, however, the commercial and industrial uses to which the basin had been subjected for so many years had taken a frightful ecological toll and the once-scenic and health-giving tidal basin had become a serious aesthetic and public health burden to the neighboring cities of Boston and Cambridge. An 1894 Metropolitan Park Commission report, for example, described the Charles River Basin as highly offensive, especially, it noted, in the section lying between the Brighton Abattoir and the Cottage Farm (now BU) Bridge, fed as it was by the discharge from public sewers and the refuse that poured into the river from the great Brighton slaughterhouse. Here deep deposits of filth were left on the river's sloping banks at every low tide. Despite greater dilution from

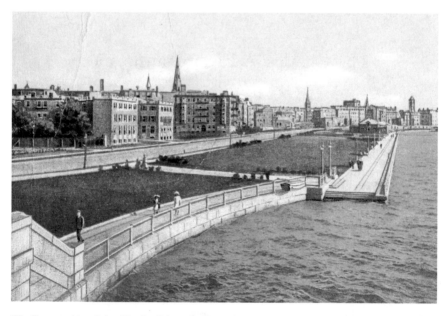

The Boston side of the Charles River shore assumed its present shape gradually over a period of forty years. First came the construction of a new seawall and the laying out of a strip of parkland called the Esplanade, extending all the way to the Charlesgate, the point at which Frederick Law Olmsted's newly developed Fenway flowed into the Charles.

the sea, the lower section of the basin was also seriously polluted, receiving discharges of contaminants both from public sewers and the many pork packing plants of East Cambridge, likewise causing "offensive deposits to form upon the flats."

Important steps were taken as early as the 1880s and 1890s to improve the appearance of the basin. These included such measures as the construction of protective embankments on both the Boston and Cambridge sides; the creation, in 1889, of a ten-acre park (the Charlesbank) in the area east of the West Boston Bridge, chiefly for the residents of Boston's crowded West and North End neighborhoods (this pioneer park, designed by Frederick Law Olmsted, featured two gymnasia, a children's playground and a handsome riverfront promenade); the laying out on the Allston-Brighton shore of the mile-long Charles River Speedway for sulky racing; and the 1900 construction behind the Cambridge Embankment of elegant Memorial Drive.

Despite widespread recognition of the seriousness of the basin's pollution problem, no comprehensive improvement plan gained wide public support before 1903. In 1894, the Joint Board on the Improvement of the Charles River and the Massachusetts Board of Health had recommended that the tides be permanently excluded from the river through the construction of a dam at its mouth. However, this plan failed to win immediate approval. A number of facets of the plan generated opposition. The most controversial provision was a proposal to allow new buildings to be constructed on the land salvaged from the river in Boston's Back Bay, which would have deprived the owners of preexisting residences on the north side of Beacon Street of their riverfront views. There was concern also that the damming of the Charles might contribute to the silting up of Boston Harbor, which was already suffering from declining trade; also, fear that an entirely freshwater basin might become a breeding ground for malaria and other diseases.

The principal figure in the Charles River improvement initiative at this stage was the great landscape architect Charles Eliot, son of Harvard President Charles W. Eliot, who had earlier founded the Trustees of the Reservations. Eliot had been the prime mover also in the 1892 establishment of the Metropolitan Park Commission, the agency that in 1916 would become the Metropolitan District Commission, with jurisdiction over all basin parkland. The death of Eliot in 1897, at the age of thirty-seven, was a great loss to the Charles River improvement effort.

The stalled dam proposal was, however, successfully revived in 1901 by two influential Boston financiers, Henry Lee Higginson and James Jackson Storrow, who were business associates in the firm of Lee, Higginson & Company. Eliminated from the Higginson-Storrow plan was the controversial

proposal for new construction in the Back Bay. The revised damming proposal won general acceptance in 1903 with the appearance of the comprehensive *Report on the Charles River Dam*, which satisfied most of the engineering and public health objections that had previously been raised.

Thus in the period 1906 to 1908 a wooden dam was finally built across the mouth of the Charles, a measure that fundamentally transformed the character of the river. The dam permanently excluded the tides from the basin, with the water level thereafter held at a more or less constant seven feet above low tide. A permanent masonry structure replaced the wooden dam in 1910, and a handsome public park was then laid out on the earthen part of the dam behind the masonry wall (in the 1950s, this park was obliterated to accommodate the Museum of Science).

The Boston shore assumed its present shape gradually over the next forty years. First came the construction of a new seawall and the laying out of a strip of parkland extending from the Charlesbank all the way to the Charlesgate, the point at which Frederick Law Olmsted's newly developed Fenway flowed into the Charles. Then, in the early 1930s, the Esplanade, as it was popularly known, was widened and lengthened by the addition of a lagoon, a sheltered landing for boats, and a space for concerts. In 1939, the Hatch Shell was built as a venue for concert performances. Finally, in the early 1950s, following the 1949 construction of Storrow Drive, the Esplanade was again widened to compensate for the loss of land taken for the highway, and an enlarged system of lagoons, islands and pedestrian bridges was installed. The designer of both of the latter projects was the same man, Arthur A. Shurcliff, who had earlier served as the landscape architect for Colonial Williamsburg.

Part V

Ethnic Boston

In one way or another, the six columns that follow illustrate the profound impact immigrant populations have had upon Boston and conversely, Boston has had upon its immigrants.

While the experience of the Irish has been dealt with extensively elsewhere, that of Boston's Italian immigrants, the second-largest group to enter Boston, has received scant attention. I do take up the topic of Boston's Irish in relation to the Draft Riot of 1863, in which a deeply aggrieved immigrant element rose up in protest against highly discriminatory Civil War recruitment policies, but the primary emphasis of this section of *Boston Miscellany* is on Boston's Italian community, a subject I've dealt with in countless public lectures over the years as well as in the pages of my 1999 book *The Italian Americans of Greater Boston*.

Boston's Italians were thrust into a situation of bitter ethnic warfare between the city's Yankee element, which dominated state government and the city's principal financial, cultural and philanthropic institutions, and the majority Irish, who held a firm grip on Boston's government, labor movement and the institutions of the powerful Catholic Church. Late-arriving immigrant groups, like the Italians, fell between two stools, as it were, and on that account made somewhat slower economic and political progress in the Hub than elsewhere in the United States.

The Spanish Influenza Epidemic of 1918 was nowhere more devastating than in Boston's terribly crowded North End, producing a mortality rate that prompted the city's Italian leadership to establish the Home for Italian Children. The sad story of the Sacco-Vanzetti wake and funeral dramatically underscores the hostility that Italians faced in Boston as late as 1927.

The Boston Draft Riot of July 14, 1863

The bloodiest riot in Boston's history occurred not in the pre-Revolutionary period—one thinks immediately of the 1770 Boston Massacre when riots are mentioned—but in 1863, in the third year of the American Civil War. It involved a violent protest by the residents of the then-predominantly Irish North End against the implementation of the General Conscription Act, which the U.S. Congress had adopted that March. This legislation subjected all male citizens between the ages of twenty-five and thirty-five to the draft, but also allowed anyone who could afford to pay the government $300 to avoid military service. The act was accordingly regarded as highly discriminatory by the city's poor, of whom the Irish comprised the great majority. When the army sought to enforce this law, riots broke out in poor urban neighborhoods throughout the Union. In Boston's case, anti-draft rioting resulted in the deaths of at least eight residents and the injury of countless others.

The Boston Draft Riot began at about 12:30 p.m. on July 14, 1863, when two officials of the Provost Marshall's Office, David Howe and Wesley Hill, attempted to deliver draft notices on Prince Street in the North End.

As the officers proceeded on their rounds, an angry crowd formed, urging resistance to the draft. When the notice servers reached 146 Prince Street, opposite the Boston Gas Company plant (the largest industrial establishment in the North End), a verbal altercation with a draftee sparked the day's violence. Gas plant employees, who were outside for their noon hour break, joined in the assault on the officers. Hill succeeded in evading his attackers and fled the scene, but Howe was not so lucky. The angry mob cornered the unfortunate man, pushing, shoving and striking him upon the head.

Fortunately, a police officer, Romanzo H. Williams, who arrived on the scene as the attack began, rescued the battered victim and brought him to a store at the corner of Prince and Commercial Streets, where his wounds were treated. However, when the police officer then tried to escort Howe to his nearby lodging house, the crowd, which was steadily growing in size, set upon the injured official a second time, threw him down and beat him much more severely. Though Howe survived even this second beating, other Bostonians were not so lucky that day.

A force of policemen, detailed to contend with the disturbance on Prince Street, now arrived and succeeded in dispersing the mob, but not before several of its officers were injured and bruised. Mob activity had meanwhile spread to North Street and to the Haymarket Square and Faneuil Hall areas. So dangerous had the situation become by mid-afternoon that many storekeepers closed their shops.

Boston Mayor Frederick Walker Lincoln, a Republican who resided in Louisburg Square, though a descendant of Revolutionary-period rioters (a great grandson of Paul Revere), showed scant sympathy for the 1863 rioters, using military force to suppress the demonstrations against the discriminatory General Conscription Act.

Fearing further disturbances, city and state officials began calling in troops from various military installations near Boston. A company of one hundred soldiers from Fort Independence, members of the Third Artillery Regiment, reached the city at about 5:00 p.m. They were paraded up State, Washington and Court Streets in a display of force. "Their presence in the city was quite generally welcomed," the *Boston Herald* reported.

Additional troops were held in readiness. The First Battalion of Dragoons was notified to stand by and the Forty-fifth Regiment was ordered to assemble at the Readville military camp. Governor John Andrew also ordered militia companies from the nearby towns of Charlestown, Cambridge, Roxbury, Somerville and Medford to converge on the city.

Of particular concern was the security of the arms and ammunition stored at the North End's Cooper Street armory. If these weapons were to fall into the hands of the anti-draft mob, who knew what havoc might ensue.

A detachment of infantry from Fort Warren, under the command of Captain E.J. Jones, was immediately dispatched to Cooper Street to reinforce the facility. In the course of the afternoon, cannons and other weapons were sent to Cooper Street from Readville.

By 8:30 p.m., an angry mob, several hundred strong, had gathered outside the Cooper Street armory. The attack that followed came perilously

close to succeeding. Since few of the rioters had guns, they were reduced to tearing up the street and sidewalks near the armory and hurling loosened bricks and paving stones against the facility's door and windows in an attempt to break in.

Having received strict orders from Boston Mayor Frederick W. Lincoln to hold the armory at all costs, Captain Jones had positioned cannons directly behind its two entrances. When the mob succeeded in battering open one of these portals, Jones ordered this gun to open fire. As the *Boston Post* reported of the bloody scene: "Finding matters had reached a crisis, and all warnings having failed, and finding moreover that the mob was likely to prevail, he ordered one of his field pieces, loaded with canister, to be discharged, with fatal results." Jones also gave his men leave to use their side arms at will to repel the attackers.

The result was a scene of civilian carnage such as Boston had never before witnessed. Significantly, the fullest account of the injuries inflicted in the assault appeared in the pages of the *Boston Pilot*, the city's Catholic paper, with its large Irish readership. Most of the victims were, in fact, poor Irish Catholics.

The dead and wounded included men, women and children of all ages— an unidentified laborer, age thirty, who was reported to have been "pierced by the [cannon shot] in at least eleven places" was the first to fall. Of special note were the many young people killed or severely wounded in the melee. These included a boy, age ten, who was shot through the heart; a fifteen-year-old youth, shot in the abdomen; a twelve-year-old boy shot in the hip; and another, age ten, whose left arm was shattered. A woman was fatally shot in the neck, while two other females were seriously wounded. While the projectiles the mob hurled against the armory's doors and windows injured several soldiers, none were killed. Only one death occurred inside the building. A seventy-two-year-old man, a resident of Cooper Street, who happened to be visiting the building when the attack occurred, was struck by a pistol ball and instantly killed.

While the above events were transpiring on Cooper Street, a second mob broke into the hardware and arms shop of Thomas P. Barnes at 28 Dock Square, near Faneuil Hall, seizing one hundred rifles, seventy-five pistols and four dozen bowie knives. The rioters next descended upon the store of Mr. Read in Faneuil Hall Square, where a police force under the command of Captain Dunn intervened. In the struggle that followed, James Campbell, identified by the press as the ringleader, was shot in the head and arm.

At this point, troops arrived to clear the Faneuil Hall area and to secure its approaches. The rioters were driven off and two cannons were placed at the center of the square to repel attacks. By eleven o'clock, the square had been

cleared of civilians and a steady rain was falling. For all intents and purposes, the Boston Draft Riot had ended.

Boston was not the only city to experience a draft riot in mid-July 1863. The New York City Draft Riot of July 14–16 was much more severe, resulting in 160 deaths and immense property damage. That the Boston riot lasted less than one day, took many fewer lives and caused minimal property damage has been credited to two factors chiefly: the prompt action taken by Mayor Lincoln and Governor Andrew in calling in the military, and the influence that the Catholic Church and its local pastors exerted to persuade the denizens of Boston's poorer neighborhoods to remain indoors and to desist from further violent resistance to the draft.

Despite the relative mildness of the local draft riot, however, it remains a fascinating episode in our history—a story that deserves to be better known.

Boston's Early Italian Community

While Italian-Americans comprise the second largest ethnic group in Boston, little has been written of that group's contributions to the city's history.

Italians were latecomers to Boston, arriving in significant numbers only after 1890. A mere 300 persons of Italian birth resided here as late as 1860, more than two centuries after the city's foundation. By 1880, the number had risen to a modest 1,200. The strong anti-Catholic sentiments that prevailed in the early years doubtless served to discourage immigration from Catholic Italy.

In the period before 1890, it was far more common for Bostonians to visit Italy than for Italians to settle here, for the peninsula served as a vital source of artistic and poetic inspiration for creative Americans. Many books and articles have been written about Italy's influence upon American painting, sculpture, architecture, poetry and music.

The list of Bostonians who spent time on the Italian peninsula reads like a who's who of the Yankee capital. It included the architect Bulfinch, who modeled so much of Boston's built environment along Italianate lines; the painters Copley, Allston and Morse; the sculptors Greenough and Hosmer; such key literary figures as Hawthorne, Longfellow, Willis, Appleton and Lowell; the literary critics Parsons and Norton; the historians Prescott, Parkman, Motley and Bancroft; the social critics Emerson and Fuller; the reformers Howe, Dix and Sumner; the great scholars Ticknor, Coggswell and Everett; and such eminent clergymen as Ware and Parker. The list is both long and distinguished.

The admiration Bostonians felt for Italian culture also fostered a modest Italian immigration to Boston, many coming at the behest of the city's intellectual and social leadership.

These included such notable figures as Filippo Traetta, a Venetian conductor and composer, who arrived in the late 1790s, and who soon after established the first American conservatory of music in Boston; Luigi Ostinelli, a musician of high reputation who for many years conducted the well-known Tremont Theater Orchestra; Count Lorenzo Papanti, a Tuscan nobleman who ran Boston's premier dance studio; Pietro Bacchi and Pietro Monti, both professors of Romance languages at Harvard College; the Marchese Niccolo Reggio, a prominent merchant and ship owner who also acted as consular agent for several Italian states; and Father Giuseppe Finotti, a noted Catholic historian, to name just the most prominent.

Papanti, who came in the 1820s, established his famous dance studio in palatial quarters at 17 Tremont Street, under the patronage of Mrs. Harrison Gray Otis. This fashionable establishment was a fixture in the social life of Boston's high society for nearly three quarters of a century.

The Marchese Niccolo Reggio (1810–1867), who came to Boston from Smyrna, Turkey, in 1832, was a member of the Genoese nobility. The Reggios had lived in the Italian colony in Smyrna (now Izmir) since the fourteenth

The Marchese Niccolo Reggio (1810–1867), who arrived in Boston in 1832 from the Italian colony in Smyrna, Turkey, was a major Boston export-import merchant, with offices on Central Wharf. The Reggios resided at 1 Commonwealth Avenue in Boston's fashionable Back Bay.

century, and engaged in extensive maritime activities. Niccolo was sent to Boston by the Reggio firm to handle the sale of its goods locally. He eventually married the stepdaughter of prominent Irish-American merchant Andrew Carney (the namesake of the Carney Hospital). The Marchese Reggio became a major Boston export-import merchant, who owned a fleet of seven vessels.

Despite its small population, Boston's early Italian community produced at least one celebrity of international reputation, the great coloratura soprano Eliza Biscaccianti. Born in Boston in 1824, the daughter of conductor Luigi Ostinelli and Sophia Henrietta Hewitt of Boston, *La Biscaccianti*, as she was known to her adoring fans, appeared in the great European and America opera houses of her day.

Where did Boston's Italians live between 1860 and 1890? The socially prominent resided in such upper-class neighborhoods as the South End, Beacon Hill and Back Bay. The Marchese Reggio's family occupied a fashionable townhouse at 1 Commonwealth Avenue in the Back Bay, while the city's leading Italian-American academic, Boston-born Professor Gaetano Lanza, chairman of the Department of Mechanical Engineering at MIT, resided on Mount Vernon Street on Beacon Hill.

The great majority, however, lived in more modest neighborhoods such as the North and West Ends, Charlestown, Roxbury and East Boston. The

The earliest Italians to settle in Boston included men of high social rank. Count Lorenzo Papanti, a political liberal, participated in a plot to overthrow the oppressive rule of the Hapsburg Duke of Tuscany and was exiled. Settling in Boston in the 1820s he found employment as a violinist with a local orchestra. In 1827, he established a fashionable dance studio in palatial quarters at 17 Tremont Street, which became a fixture in the social life of Boston for nearly three quarters of a century.

largest concentration lived in the North End, in the vicinity of Ferry Court, near the present Sumner Tunnel entrance. We see the faint beginnings of Boston's Little Italy in this enclave. By the 1870s, the center of gravity of the North End's Italian enclave had shifted to the North Bennett Street area. The residents of this first Italian neighborhood included aspiring merchants drawn to Boston by the opportunities in the import and export trades, most of whom hailed from the vicinity of Genoa, Italy's most dynamic commercial center.

Luigi Pastene, who arrived in Boston from Genoa in 1848, offers an outstanding example. Starting out as a modest fruit peddler, this enterprising immigrant soon established a grocery store on the North End's Fulton Street, which his son, Pietro, would later build into the well-known firm of Pastene & Company, the largest importers of Italian food in the northeast.

Another notable business success was scored by John Deferrari, born on Ferry Court in 1865. Deferrari left school at age thirteen and began peddling fruit from a basket along State Street, Boston's main financial thoroughfare. His enterprise soon graduated to a pushcart, and then to a store, the Quality Fruit Store on Boylston Street, adjacent to the old Boston Public Library. Deferrari began visiting the library on a regular basis, where he taught himself real estate law, business, economics and statistics. At the age of twenty-eight, he gave up fruit-selling and turned his talents to real estate and stocks and bonds, in which he earned a great fortune. In 1947, Deferrari gave a million dollars to the institution that had done so much to further his education, the Boston Public Library, the largest bequest that institution had ever received. The BPL's Deferrari Hall is named in the memory of this son of Italian immigrants.

The Italian enclave of the early period (1860–90) contained a disproportionately high number of artists and craftsmen (plaster workers, marble workers, painters, musicians and such). It also contained a relatively high number of teachers (foreign language, music and voice teachers were especially plentiful). The majority of its wage earners, however, were ordinary workers. Of the approximately three hundred individuals of Italian background listed in the 1874 Boston City Directory, for example, the largest number (one out of six) were day laborers, with fruit dealers, barbers, bakers, shoemakers and members of the various building trades (especially carpenters and bricklayers) making up the largest occupational groupings.

The great building boom that Boston experienced between 1860 and 1890 served to attract Italian artisans to the Hub. Much of the rich decorative work performed on the city's public buildings, churches and its great private residences was done by Italians. Isabella Stewart Gardner, for example,

employed many Italian craftsmen in the construction of Fenway Court (the present Gardner Museum). Italian craftsmen were employed in the building of the 1889–1894 wing of the Massachusetts Statehouse. A crew of Italian tile men, under the direction of Luigi Totino of the North End, for example, laid the magnificent mosaic floors in the Hall of Flags.

Boston had little difficulty accommodating this small, relatively prosperous, commercially-oriented and mostly literate immigrant element. Attesting to the relatively high level of acceptance that the city's Italians enjoyed prior to the 1890s was the selection, in 1854, of Nicholas Alessandro Apolonnio, the son of an Italian immigrant father, as Boston's City Registrar, a post the Protestant Apolonnio held with distinction for nearly forty years.

Italian Immigration at Full Tide

The number of Italians in Boston before 1890 was rather small. In the last decade of the century, however, Italian immigrants began arriving here in enormous numbers. Italians, in fact, comprised the single largest immigrant group entering the United States between 1890 and 1920.

Why did so many Italians leave their homeland in these years, and why did so many settle here in Boston?

Nearly 90 percent of these post-1890 immigrants came from the southern part of the peninsula, the so-called Mezzogiorno region, the poorest and least developed part of Italy.

Southern Italy suffered many misfortunes in the late nineteenth century. The area had been forcibly incorporated into the newly unified Kingdom of Italy in 1861. When southerners resisted consolidation, the northern-dominated government sent in troops to crush the opposition, installed a centralized bureaucracy and imposed high taxes and harsh conscription laws on an agricultural population that were already living a hand-to-mouth existence.

Even more decisive in fostering large-scale emigration, however, were the economic hardships that southern Italy suffered in the late nineteenth century. First, this primarily farming region lost its traditional wheat and citrus markets to the more advanced agricultural economies of the United States, Argentina, Australia and Canada. Then a tariff war with neighboring France deprived Italy of its principal market for grapes. To make matters worse, the Mezzogiorno was struck by a succession of devastating physical disasters, including recurrent earthquakes, volcanic eruptions, epidemics, floods and crop failures.

The crisis in the Mezzogiorno coincided with a stage in this country's development in which American enterprise had much need of huge quantities of cheap labor. Labor agents, acting for American railroads and manufacturers, aggressively promoted emigration from southern Italy in these years.

The United States offered Italians opportunities for the accumulation of savings that were simply not available in other quarters. Italians chose Boston over other localities because jobs were available here for semiskilled and unskilled workers in the construction, transportation and manufacturing sectors of the Hub's expanding economy.

Italians entered Boston suffering from a whole range of social and economic disabilities. They were the poorest group of immigrants to arrive here since the Irish potato famine immigrants of the mid-nineteenth century, coming with an average of just nine dollars in their pockets.

In addition, a large number of these turn-of-the-century immigrants had no intention of remaining permanently. Such immigrants were called "Birds of Passage." They came to find work and to accumulate savings, intending to eventually return to their homeland. Since they were here only temporarily, they had little incentive to learn English or adopt American customs. As a result, the Italian community in Boston was long characterized by a preponderance of males over females.

My own great grandfather, Pietro Salvucci, offers an excellent example of an itinerant immigrant. A married man with a young family, a stone mason by trade, he left his village, San Donato val di Comino, for America in 1898, in search of employment opportunities in construction and public works projects. Over a period of twenty-six years, he returned to Italy nine or ten times, usually during the winter months, when work in construction was scarce. Not until 1924, when the United States adopted severe immigrant restriction laws, did Pietro, faced with the possibility of permanent exclusion, transfer his family here, thereby making an irreversible commitment to this country.

Nativism and racism were also on the rise in the United States at the beginning of the twentieth century. The growing movement to restrict immigration took much of its impetus from the theories of Teutonic and Anglo-Saxon racial superiority that were coming out of such New England's cultural bastions as Harvard University. Italians were burdened with negative stereotypes that held them to be shiftless, superstitious, clannish and prone to criminal activities. Arriving moreover at a time when industrial capitalism was in the ascendant, they also became pawns in an intensifying struggle between capital and labor.

Ethnic Boston

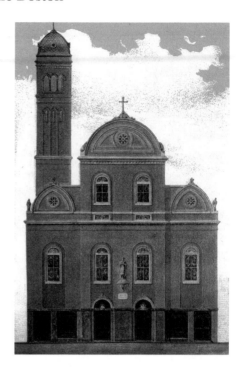

Indicative of the rise of Italians to a dominant position in Boston's North End was the establishment in 1888 of Sacred Heart Church, which offered Italian-language services. The church building, dating from 1828, earlier served as a Protestant house of worship, the Seamen's Bethel, which attended to the spiritual needs of mariners.

In addition, Boston presented special dilemmas for the Italian immigrant. Until the mid-nineteenth century, the Hub had been a predominately Anglo-Protestant city. Then, in the post-1846 period, Boston's ethnic and religious complexion changed dramatically with the arrival of vast numbers of Irish Catholic immigrants, driven from their homeland by the great potato famine. The Irish were obliged to wage a long and difficult battle for recognition and advancement in the years that followed. Boston eventually became the only major city in the United States in which they comprised a majority of the electorate. By the early twentieth century, the Irish had established a firm grip on the city's politics, public employment, labor movement and Catholic Church.

Meanwhile, the older Anglo-Protestant element, the Yankees, retained control of the state government, as well as the city's primary business, financial, cultural and philanthropic institutions. Late nineteenth-century immigrants—Italians, Jews, Slavs, Lithuanians, Poles, Greeks, Armenians, etc.—were effectively excluded from both spheres.

Other disabilities were internal to the Italian community itself, which was deeply riven with political and social divisions. The community lacked cohesion. Italians tended to self-segregate by place of origin—Neapolitans preferring to live with fellow Neapolitans, Sicilians with Sicilians, Calabrians with Calabrians. Also, the earlier-arriving immigrants, mostly northern Italian

This postcard view of a North End street, labeled "Little Italy, Boston, Mass.," gives a sense of the congestion that prevailed in the crowded North End in the early years of the twentieth century.

in background, looked down on the later-arriving southern immigrants, showing little concern for their welfare. The class attitudes and social distinctions that ran deep in Italian society were transferred to America.

The North End, with its preexisting Italian enclave, continued to serve as the group's primary enclave, though Italians also settled in many surrounding towns in significant numbers.

The downtown enclave—with its Italian stores, Italian language churches and the services of Italian doctors, lawyers, labor agents, travel agents and other professionals—provided the immigrant with a relatively familiar and manageable environment. By the early 1920s, the Italian population of the downtown enclave (the North and West Ends) approached fifty thousand.

Employment opportunities were plentiful in the downtown—jobs abounded in nearby factories; on the waterfront; in area railroad yards and truck depots; with the construction crews' local padrones (labor agents); and in the adjacent market district, where Italians found employment as vendors of meat, fruit and vegetables. While jobs were plentiful, the work tended to be low-paying as well as physically exhausting.

The downtown enclave also provided critically important patronage for aspiring entrepreneurs. Some of Boston's most successful Italian businessmen got their start in the central enclave as produce merchants,

bakers, undertakers, pharmacists, liquor dealers, tailors and restaurant proprietors. Perhaps the best example of a major business success was the Prince Macaroni Company, founded by three Italian immigrants on the North End's Prince Street in the early 1900s.

The Spanish Influenza Epidemic of 1918

In the final weeks of World War I, as American and Allied forces made steady progress against their German and Austro-Hungarian foes in Europe, a far more dangerous enemy was advancing against the human species at large. In the brief space of four months, that silent bacteriological menace, the Spanish influenza, wiped out an estimated forty million men, women and children, exacting a far greater toll of human life than any scourge humanity has suffered before or since.

Medical historians believe the 1918 epidemic's point of origin to have been a January 1918 swine fever outbreak in Iowa. At the time, however, there was much uncertainty as to the source of this incredibly potent disease. It was dubbed the *Spanish* influenza only because Spain's King Alfonso XIII was its earliest prominent sufferer.

The 1918–19 Influenza Pandemic (world-wide epidemic) reached virtually every corner of the United States. In the last week of October 1918, at a time when 2,700 Americans lost their lives in the European fighting, the Spanish influenza killed 21,000 Americans. Moreover, Boston and surrounding towns suffering a particularly severe outbreak of the disease.

This new and powerful form of influenza was first detected locally in August 1918 among the personnel of the naval facilities near Boston, and was therefore assumed to have been brought in by ship from Europe. It quickly spread from the naval installations to the U.S. army training camp at Fort Devens in Ayer, Massachusetts, where 6,800 cases were recorded by late September.

The symptoms began with a cough lasting two days, followed by pain behind the eyes, in the ears and in the lumbar area. Next came drowsiness and fever, with temperature often rising as high as 104 degrees, accompanied by a rapid and unstable pulse rate, a thickly coated tongue and an inability to eat. At its height, every part of the body ached excruciatingly—especially the respiratory system. It took the disease three days to run its course.

The first influenza-related Boston death occurred on September 8. From that point on, however, the number of fatalities mounted steadily until October 1, when 202 deaths were recorded in the city, the maximum number on any single day.

INFLUENZA

How to Avoid It—How to Care for Those Who Have It

The following suggestions of the Massachusetts State Department of Health may prove of immeasurable value to any man or woman who will read, remember and act upon them in the present great emergency. The counsel here set forth has been prepared after consultation with some of the ablest medical men in America. If you will follow the dictates of this official bulletin, you will be doing your duty to your fellow man and to yourself.

What To Do Until the Doctor Comes

If you feel a sudden chill, followed by muscular pain, headache, backache, unusual tiredness and fever go to bed at once.

See that there is enough bed clothing to keep you warm.

Open all windows in your bedroom and keep them open at all times, except in rainy weather.

Take medicine to open the bowels freely.

Take some nourishing food such as milk, egg-and-milk or broth every four hours.

Stay in bed until a physician tells you that it is safe to get up.

Allow no one else to sleep in the same room.

Protect others by sneezing and coughing into handkerchiefs or cloths, which should be boiled or burned.

Insist that whoever gives you water or food or enters the sick room for any other purpose shall wear a gauze mask, which may be obtained from the Red Cross or may be made at home of four to six folds of gauze and which should cover the nose and mouth and be tied behind the head.

Remember that these masks must be kept clean, must be put on outside the sick room, must not be handled after they are tied on and must be boiled 30 minutes and thoroughly dried every time they are taken off.

This notice offering advice on how to avoid contracting the Spanish influenza, as well as how to care for its victims, appeared in the *Boston Globe* on October 6, 1918.

After October 1, the death rate gradually subsided, except for the period just after November 11 (huge crowds having gathered in Boston to celebrate the German armistice) and after the Christmas Holidays (which brought the usual crowds of shoppers into the city).

In total, the four-month epidemic took 4,794 lives in the city of Boston. Since only about 2 percent of Spanish influenza victims died from the disease, Boston Health Department officials estimated that as many as 240,000 of the city's 784,000 residents, or 31 percent of the total population, may have contracted it before it ran its course.

One of the most fascinating aspects of the epidemic was the failure of the media to respond to the outbreak with greater alacrity. Early reports were buried on the inside pages of the city's newspapers and suggested that health officials had the situation well in hand. The two major Boston newspapers of the period, the *Post* and the *Globe*, for example, gave the epidemic only minor notice until its worst effects had peaked. Not once in the five weeks between September 1 and October 7, 1918, did either paper devote a banner headline to a phenomenon that was taking the lives of thousands of Bostonians. Only on September 22 did an influenza-related story appear on page one, when mention was made of the death of a prominent local official, Boston postmaster and former congressman William F. Murray.

Stories about the epidemic began to appear on the front pages with regularity only in the last week of September, at a time when six hundred influenza-related deaths were recorded in the city, and even then influenza stories played second fiddle to news from the war front. A September 26 article announcing the closing of theatres and schools, for example, appeared under a banner headline declaring "Bulgar Army Now Close to Disaster."

Governmental agencies were equally delinquent in addressing the crisis. While the 1919 *Annual Report of the City of Boston Health Department* reported that circulars were issued containing instructions on the care of those infected with influenza, that theatre managers were urged to issue warnings on screen about sneezing and coughing, that placards were posted warning against spitting and that advertisements were run in the city's papers giving advice with respect to the disease, such measures were taken at a late stage in the disease's progress, and therefore had rather limited impact. The first instructional circular published in the *Globe*, for example, appeared there on October 6, several days after the influenza had reached its peak.

Ironically, the Boston papers gave much more attention to the national Liberty Loan drive then underway than it did to this killer epidemic, appeals for the purchase of war bonds appearing on their pages on a daily basis. The rallies these advertisements helped promote acted as a seedbed for the spread of the highly contagious disease then spreading across the city.

Not until the last week in September were the city's schools, theatres, movies, bowling alleys, barrooms and soda fountains ordered closed. On September 27, wakes were prohibited. On September 28, regulations were adopted regarding cups, spoons and other utensils. A ban on church services came only on October 4. While William Cardinal O'Connell offered facilities at St. John's Seminary in Brighton as a home for convalescents, Boston's leading Roman Catholic prelate also objected to the proposed ban on church services on the grounds that prayer would be more efficacious in stemming the disease than any of the preventive measures city and state health officials were proposing.

The influenza's impact was particularly severe in the city's most congested neighborhoods, but no quarter of the metropolis was safe. Congressman John W. McCormack recounted of his South Boston neighborhood, "You couldn't walk down any street…without seeing the black mourning wreath on every door…it was horrible."

The public health circulars published during the epidemic appeared in three languages: English, Italian and Yiddish, for it was the Italian and Jewish communities in Boston's North and West Ends that were the most severely effected. The mortality rate in the North End (the most congested

neighborhood in Boston) was so high that its leaders were prompted to found the Home for Italian Children in October 1919 to care for those orphaned by the epidemic.

If congestion furnished a breeding ground for influenza, it soon became obvious that open spaces and fresh air offered the best prospect for recovery. This was demonstrated by the high rate of recovery at a temporary tent hospital on Corey Hill in Brookline. Given that none of the established medical facilities of Boston had space for servicemen who had contracted the disease while stationed at military facilities on the Boston waterfront, two officials of the Recruiting Service, Dr. Louis Croke and Henry Howard, hit upon the idea in October of creating a temporary tent hospital in the countryside to receive the afflicted men. While many of the Corey Hill facility's patients were in advanced stages of the disease, the cool breezes and sunshine of that elevated, sparsely populated suburban site fostered a much higher rate of survival from the dreaded disease than any of the established hospitals in the inner city.

Burying Sacco and Vanzetti

The largest and most contentious funeral ever held in Boston took place on August 28, 1927, when the bodies of Nicola Sacco and Bartolomeo Vanzetti were transported from the North End's Little Italy to the Forest Hills Cemetery in Jamaica Plain for cremation, in the culminating event of the most controversial trial of the century.

Sacco and Vanzetti were Italian immigrants and political radicals, philosophical anarchists who espoused the overthrow of the United States government and the capitalist system.

Between 1920 and 1927—the seven years between their arrest on charges of having murdered two security guards in a South Braintree holdup and their August 22, 1927 execution at the Charlestown State Prison—was a time of intense anti-radical sentiment in the United States, when the civil rights of those even suspected of harboring radical views were routinely violated.

It was in the context of the so-called Red Scare that the two immigrants were taken into custody on May 15, 1920, and charged with murder. Vanzetti, age thirty-two, a northern Italian, was a fish peddler by trade. Sacco, age twenty-nine, a southern Italian, was a skilled shoe worker. Both had come to America in 1908.

Left-wingers quickly took up the cause of the Italian radicals. A Sacco-Vanzetti Defense Committee was organized to raise money to meet their

legal expenses. Right-wingers were equally insistent on their guilt. Even the Italian community, which had its own deep political fissures, was of two minds on the issue. The case of the poor shoemaker and fish peddler quickly became an international *cause célèbre*.

Most historians agree that the handling of the Sacco-Vanzetti trial by presiding Judge Webster Thayer was blatantly prejudicial. This intensely anti-radical and anti-immigrant judge refused to allow evidence to be presented by Italian witnesses that placed the defendants elsewhere at the time of the South Braintree murders. After the guilty verdicts were rendered, Thayer boasted to an acquaintance, "Did you see what I did to those anarchist bastards!"

In addition, the Yankee establishment, which dominated Massachusetts's political and legal systems, abetted the injustice. Harvard President A. Lawrence Lowell (a longtime immigrant restrictionist) presided over a blue ribbon panel that declared the trial's procedures to have been fair. On the basis of the Lowell panel's report, Governor Alvan Tufts Fuller refused to

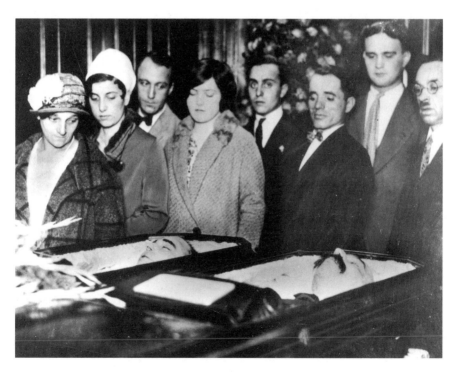

Sacco and Vanzetti's wake was held in the crowded Langone Funeral Home on Hanover Street in Boston's North End when property owners refused to provide a larger facility. At least 100,000 visitors are believed to have attended this singular wake.

commute Sacco and Vanzetti's death sentences. While Sacco and Vanzetti were tried for murder, they were found guilty for their political radicalism. As Barbara Miller Solomon wrote in her classic study of Yankee-immigrant relations in New England, *Ancestors and Immigrants*: "In Boston the pair of Italians had become a symbol of alien mindedness, an evil to be stamped out of a Yankee society determined to preserve itself and its culture."

After seven years of unsuccessful appeals for a new trial and for clemency, Sacco and Vanzetti were electrocuted by the Commonwealth of Massachusetts at midnight on August 22, 1927.

The focus of the controversy now shifted to the kind of funeral that the two men should receive.

The Sacco-Vanzetti Defense Committee hired North End undertaker Joseph A. Langone to handle the arrangements. Since his establishment at 315 Hanover Street was too small to accommodate the large number of people expected to attend the wake, a larger space was sought. Property owners, however, refused to rent their premises for such a purpose. When the committee announced that it would lay the bodies out in its own offices on the third floor of 256 Hanover Street, the owner of the building placed a piece of two-by-four lumber at the center of the entrance so as to make it impossible to bring the caskets through the doorway. In the end, the Sacco and Vanzetti wake was held in Langone's cramped Hanover Street premises.

The huge concourse of humanity that passed through the Langone Funeral Parlor over the next three days was a singular event in Boston's history. At least 100,000 people are believed to have attended the wake. At times, those waiting to view the last remains of Sacco and Vanzetti formed a line a third of a mile long. So vast was this throng that the tile floor of the Langone establishment began to crack under its weight.

The funeral procession that conveyed the bodies of Sacco and Vanzetti from the North End to Forest Hills Cemetery on Sunday, August 28, presented further problems. The weather was unfavorable, with rain falling throughout the day. The procession began shortly after noon at North End Park on Commercial Street. The line of march was slated to move up Hanover Street into Scollay Square, then proceed along Tremont Street through the South End as far as Roxbury Crossing, along Columbus Avenue, through Egleston Square to Washington Street and finally up Washington Street to the Arborway and into the Forest Hills Cemetery, a total distance of eight miles. As many as 50,000 marched in the first two miles, with another 200,000 onlookers lining the sidewalks. However, only a small number of the 50,000 ever reached Forest Hills Cemetery.

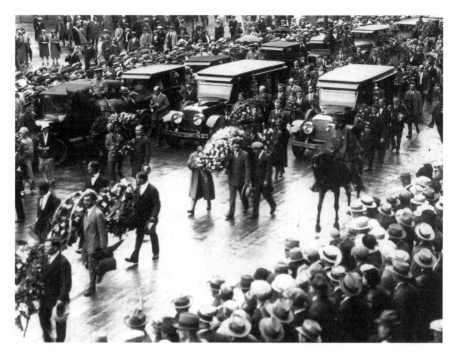

The start of the Sacco and Vanzetti funeral procession under rainy skies.

The authorities were determined to minimize the opportunities for political disturbances by keeping the procession under tight control. Seventy mounted policemen and another five hundred on foot were assigned to accompany the procession across the city.

The Defense Committee had wanted the funeral cortege to pass in front of the Massachusetts Statehouse as a form of silent protest, but the authorities, fearing that the angry mourners might attack the capitol, refused permission. To make certain that the cortege stayed away from the statehouse, Park Street and other approaches were heavily barricaded.

The giant funeral proceeded without further incident until it reached the vicinity of Arlington Street in the South End, where the principal mourners, family members primarily, who had until then been on foot, were ordered by the police to board cars for the remainder of the trip. As these vehicles sped away, led by Police Superintendent Crowley, the many thousands left behind rushed forward in a vain effort to catch up. The police hoped to put an end to the procession here in the South End. Mounted policemen waded into the crowd with the object of dispersing the multitude. But the marchers refused to give way. Instead they linked arms across the whole width of Columbus Avenue, moving forward irresistibly.

With the arrival at the Forest Hills Crematorium of the chief mourners, a brief service was held before the bodies of Sacco and Vanzetti were consigned to the flames. About five thousand spectators, who had come by streetcar or automobile, had taken up a position on a grassy knoll overlooking the crematorium. Once the service ended, however, the crowd quickly melted away in a heavy downpour.

Meanwhile the main body of mourners was still moving relentlessly toward the cemetery, their numbers now reduced to a few thousand. As the procession neared Forest Hills Station, the most serious instance of violence of the day occurred. Derisive shouts of "Guineas!" and "Go Home!" were heard from hostile residents. Here, for a second time, the police attempted to stop the procession, but the marchers again linked arms in a column extending from curb to curb. This time, however, the constabulary charged the procession with nightsticks drawn. Clubs and fists were freely used, and soon a dozen men and women lay sprawled on the cobblestones. The authorities then herded the marchers back along Washington Street to the Green Street Station. A handful who managed to evade this dragnet and reached the Forest Hills Cemetery found the ceremony concluded and the guarded crematorium impossible to approach. Thus ended the singular Boston funeral of Nicola Sacco and Bartolomeo Vanzetti.